Amazing
Mosaics

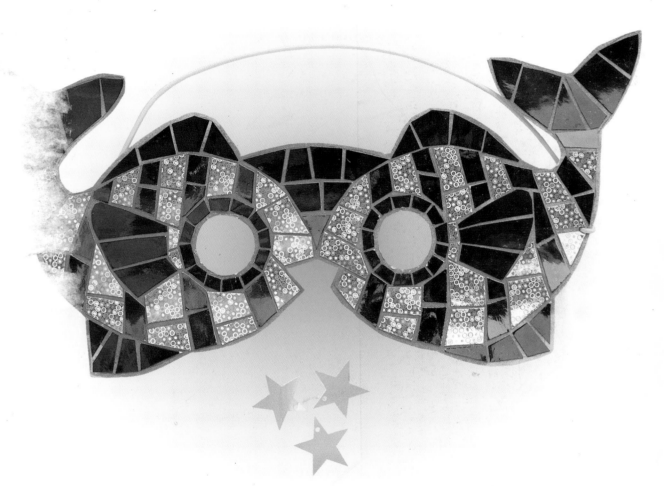

Sarah Kelly

Red Fox

Contents

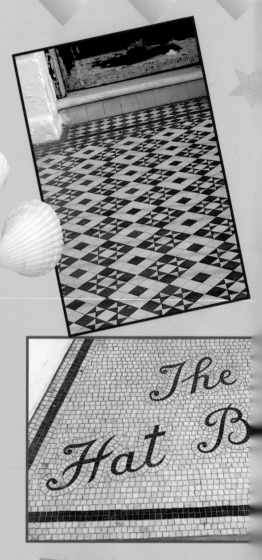

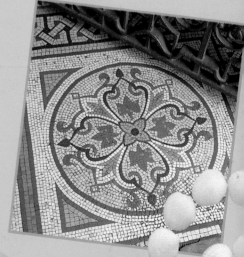

A Red Fox Book

Published by Random House Children's Books, 20 Vauxhall Bridge Road, London SW1V 2SA

A division of The Random House Group Ltd, London, Melbourne, Sydney, Auckland, Johannesburg and agencies throughout the world

Text and illustrations copyright © 2000 Sarah Kelly

Printed in Hong Kong THE RANDOM HOUSE GROUP Limited Reg. No. 954009

ISBN 0 09 940793 0

Introduction

MOSAICS ARE EVERYWHERE!
Start looking around and you will notice mosaic on **floors** in **galleries** and **museums**, on the walls of **shops** and **banks**, on doorsteps, in **swimming pools**, in **subways** and on the Underground. You may even be lucky enough to live in a place that has a mosaic as part of a historical or artistic feature. Mosaic has been used for thousands of years as a **hard-wearing** and **decorative** way of covering all sorts of surfaces. The first mosaics appeared around **3000** BC in what is now **Iraq**, and the **Aztecs** of Mexico used tiny pieces of turquoise stone to cover masks and other ceremonial objects.

Mosaic really became widespread in **Roman** times. At first they used intricate **geometric** patterns to cover the floors of villas and public buildings, but soon they were producing decorative wall panels that **featured** scenes from **legends**, as well as images of the **gods** and **goddesses** they worshipped.

Examples of their work can be seen in **North Africa** and **Italy**, and other European countries that made up the huge Roman Empire. Roman mosaic pieces were called *tesserae* and were made of pebbles, chips of marble or stone in natural earthy colours. Then, in the **Byzantine** period, the use of **tiny**

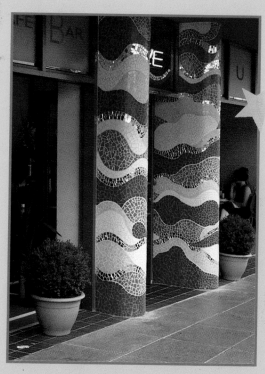

pieces of brightly coloured **glass**, called *smalti,* was introduced. For the first time, realistic colours and subtle shading could be used to produce beautiful religious images and life-like portraits of the emperors and other important people. Examples can be found in **Turkey**, **Greece** and other countries that border the **Mediterranean**.

As time progressed, mosaic work became so **refined** and technically accomplished that sometimes it looked more like painting. The designs became less **decorative** and more **realistic**. By the eighteenth and nineteenth centuries, people were even doing '**micromosaics**', mosaics that were only a few centimetres wide!

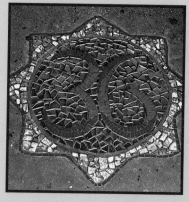

The art movement known as **Art Nouveau** brought mosaics back to being used as large-scale decorative pieces. In the late nineteenth century an Austrian artist called **Gustav Klimt** designed some of his wall **murals** to include areas of mosaic in swirly abstract patterns. Later on, a Spanish architect called **Antoni Gaudi** transformed areas of Barcelona with **buildings**, which he covered in fantastic mosaic shapes made out of broken **ceramic tiles.**

Nowadays, mosaic is used as a way of decorating anything from **bathrooms** to **gardens**, using a variety of materials including **glass**, **ceramic**, **stone**, **mirror** and even **shells**. Lots of different styles, both old and new, can be seen all over the world, so keep your eyes open wherever you go!

Getting started: Materials

In this book most of the mosaics are made from different types of coloured paper. Some of these you may already have or be able to find around the house. Most art shops and good stationers stock a variety of coloured and special paper. Start gathering together the following materials now, so you have a good collection when you begin the projects.

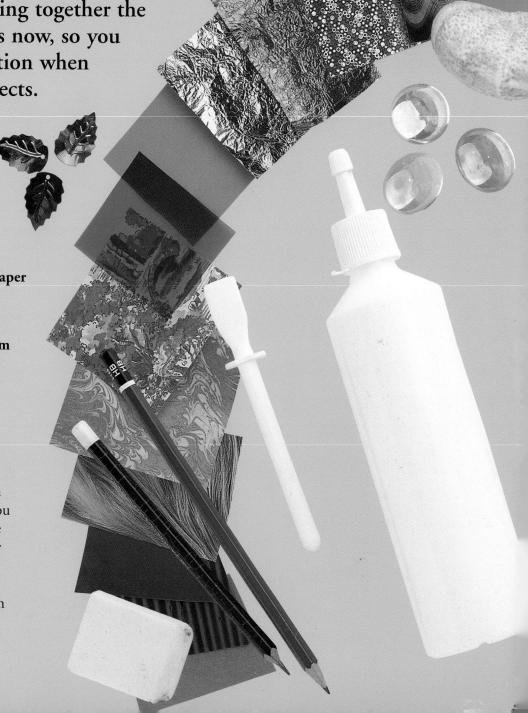

PAPER

- Plain paper in bright colours
- Glossy magazines
- Patterned paper such as wrapping paper or wallpaper
- Coloured foil
- Coloured cellophane
- Sweet wrappers made from foil or cellophane
- Holographic foil paper
- Fluorescent paper
- Handmade paper

CARD

Most of the projects use thin card as a base to work on. You can buy coloured card or use acrylic paint or ink to colour plain white card. Don't use powder paint as it will start to smudge when you stick on the paper pieces.

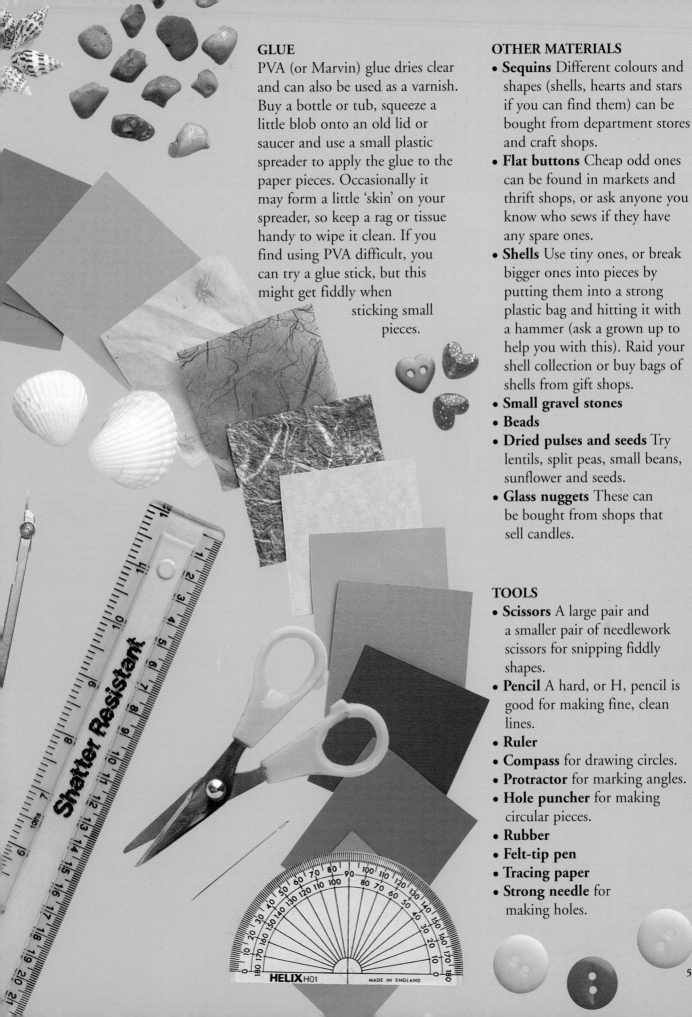

GLUE

PVA (or Marvin) glue dries clear and can also be used as a varnish. Buy a bottle or tub, squeeze a little blob onto an old lid or saucer and use a small plastic spreader to apply the glue to the paper pieces. Occasionally it may form a little 'skin' on your spreader, so keep a rag or tissue handy to wipe it clean. If you find using PVA difficult, you can try a glue stick, but this might get fiddly when sticking small pieces.

OTHER MATERIALS

- **Sequins** Different colours and shapes (shells, hearts and stars if you can find them) can be bought from department stores and craft shops.
- **Flat buttons** Cheap odd ones can be found in markets and thrift shops, or ask anyone you know who sews if they have any spare ones.
- **Shells** Use tiny ones, or break bigger ones into pieces by putting them into a strong plastic bag and hitting it with a hammer (ask a grown up to help you with this). Raid your shell collection or buy bags of shells from gift shops.
- **Small gravel stones**
- **Beads**
- **Dried pulses and seeds** Try lentils, split peas, small beans, sunflower and seeds.
- **Glass nuggets** These can be bought from shops that sell candles.

TOOLS

- **Scissors** A large pair and a smaller pair of needlework scissors for snipping fiddly shapes.
- **Pencil** A hard, or H, pencil is good for making fine, clean lines.
- **Ruler**
- **Compass** for drawing circles.
- **Protractor** for marking angles.
- **Hole puncher** for making circular pieces.
- **Rubber**
- **Felt-tip pen**
- **Tracing paper**
- **Strong needle** for making holes.

Getting started: Techniques

No matter how experienced you are, it does take time to make a mosaic, but the longer you spend and the more you practise, the better the result will be. You may find it fiddly at first, especially if the pieces are quite small, so using larger pieces may help.

Before you start, read each project through carefully to understand exactly what needs to be done at each stage. The projects are designed to get more challenging as you become more practised in the mosaic technique, so try to work through the book and not skip straight to the more complicated ones at the end! New techniques are introduced project by project, but there are a few basic things that you need to think about right from the start.

DRAWING

Always draw your outlines in pencil. Don't make the line too dark and heavy, and rub out any lines that are showing when your mosaic is finished. If the background colour is very dark, use a white or light-coloured pencil instead.

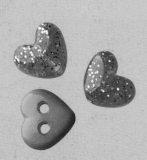

The templates at the back of the book will help you when you start doing the projects. There are two ways you can use them. Either you can photocopy the page, cut out the template and draw round it on the sheet of card, or you can trace it down. Take a sheet of tracing paper, then draw round the template with a pencil. Lay the tracing paper pencil-side down on the card, secure it at the top with pieces of masking tape so that it doesn't slip, and trace over the design – it should come out perfectly on the card!

CUTTING

Cut strips of paper to the width given in each project and then snip them into squares. Don't worry if they're not completely even all the way along or the squares aren't perfect.

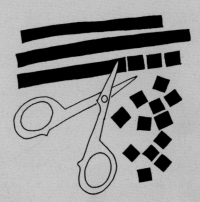

When you are laying squares round curves you need to cut them so they fit together properly. Cut the squares so that they are wider at the top than at the bottom and stick them down with the widest part on the fattest part of the curve.

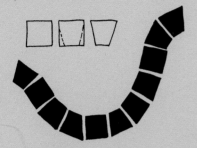

As the space remaining gets smaller, you need to cut the squares into specific shapes to fit. You can do it by eye, or by laying the square over the space and then marking where you need to cut it with a pencil.

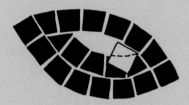

GLUING
Before you start gluing, protect your work surface by putting down newspaper. Use a small amount of glue on the plastic spreader and wipe it frequently to keep it clean. You'll get the best results by applying glue to each piece individually, but if you find this is too fiddly, then you could try this method: spread some glue onto a small area of the card and push the pieces straight onto it. Only do this if you're using PVA and if you have used acrylic paint or waterproof ink, otherwise the colour might run.

PLACING
Always lay the pieces next to each other, working in lines. Leave small gaps between each piece and try to keep the gaps the same size throughout your mosaic. Do any important details like eyes or fins first. Always do the foreground, before the background.

Start by working around the outline of your subject and then work inwards in 'rings' so that the shape remains clear when the mosaic is finished.

After a while, you will start to develop a rhythm when laying the pieces and learn to see what shapes will fit where. Try to keep the lines flowing, and don't be afraid to go over a pencil line or cut a corner if it looks more natural that way.

BACKGROUNDS
There are two ways you can do the background. One way is to follow the outline of the subject and work outwards. The other way is to lay the pieces in horizontal or vertical lines and cut them to fit where the line hits the edge of the subject.

The projects will suggest card colours for the backgrounds to your mosaic, but when you are making up your own designs make sure that the card colour is not the same as any of your mosaic pieces, or they will not be visible. Remember, mosaics are not made by machines so there will always be a bit of perfectly natural human error involved. They are not meant to be completely perfect, so don't worry if some lines are not straight or some pieces overlap. All these things give your mosaic a unique charm and make them look much more authentic! Your finished pieces don't need to look exactly like the examples in the book to be attractive. Tackle each project in your own way and learn the best way of doing things as you go along. You can use the ideas as inspiration for projects of your own that you can develop in your own style. The most important thing is to have fun.

Golden sun

Simple mosaic techniques are used to create a beautiful big sun with fiery rays, or a sparkling star.

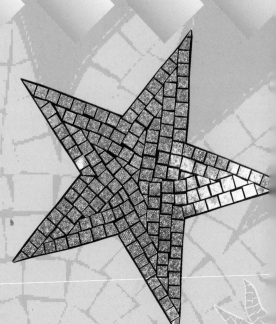

YOU WILL NEED

- **A sheet of thin white card**
- **Yellow paper**
- **Scissors**
- **PVA glue and small plastic spreader**
- **Pencil and rubber**

1 Draw the outline of a sun in the middle of the card. Make it as big as you like!

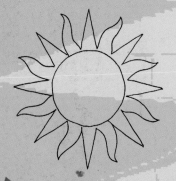

2 Cut the yellow paper into strips about 1-1.5cm wide and then cut them to make lots of little squares. The bigger your sun, the more squares you'll need.

3 Starting with the circular part of the sun, glue the squares around the outer edge leaving a small gap between each one.

4 Continue working inwards in 'rings' of squares. As you get further into the circle, cut the edges off the squares so they fit together snugly.

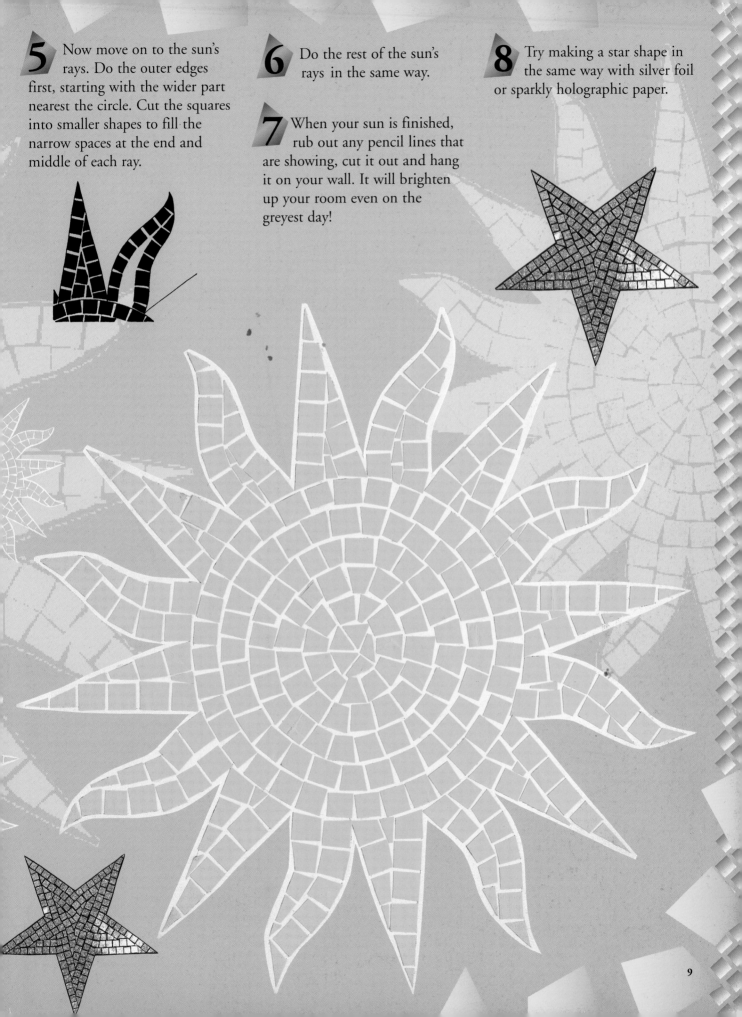

5 Now move on to the sun's rays. Do the outer edges first, starting with the wider part nearest the circle. Cut the squares into smaller shapes to fill the narrow spaces at the end and middle of each ray.

6 Do the rest of the sun's rays in the same way.

7 When your sun is finished, rub out any pencil lines that are showing, cut it out and hang it on your wall. It will brighten up your room even on the greyest day!

8 Try making a star shape in the same way with silver foil or sparkly holographic paper.

Knobbly seahorse

Use a natural material, like pieces of broken shell or tiny pebbles, to make a lovely knobbly seahorse.

YOU WILL NEED

- **A sheet of thick card 30 x 17cm**
- **Blue and green acrylic paint**
- **Tracing paper**
- **Broken shells or very tiny stones**
- **A small flat button**
- **PVA glue and small plastic spreader**

1 Paint the sheet of card, mixing streaks of blue and green to get a watery effect.

2 Choose shells or stones that are roughly the same colour and wash and dry them carefully. Break up the shells by putting them into a strong plastic bag and smash them with a hammer (ask a grown up to help you with this).

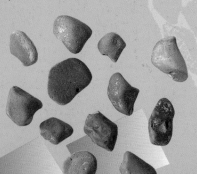

3 Trace the seahorse template on p. 38 onto the sheet of card (see p. 6).

4 Stick on the button for the seahorse's eye.

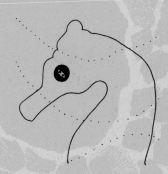

5 Start to fill in the seahorse with the shell pieces or stones. Do the head first and work down the body, leaving a small gap between each piece. Always stick one piece next to another. Don't worry if you go over the edges of the outline.

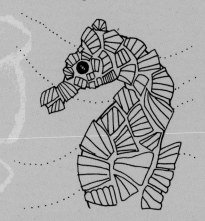

TIP
Use smaller pieces in the narrower areas such as the nose and tail and bigger pieces for the body.

6 Leave your mosaic flat for a few hours until the glue has completely dried.

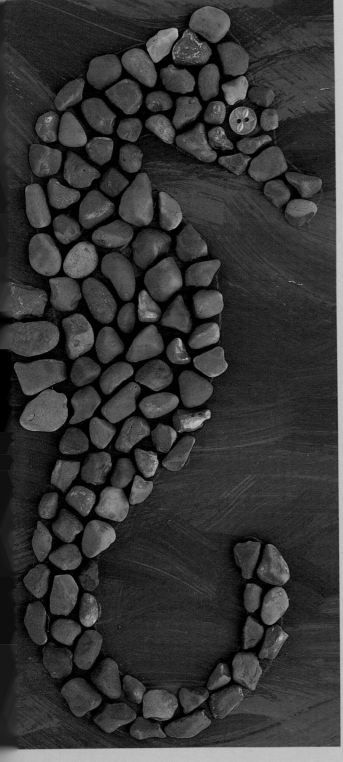

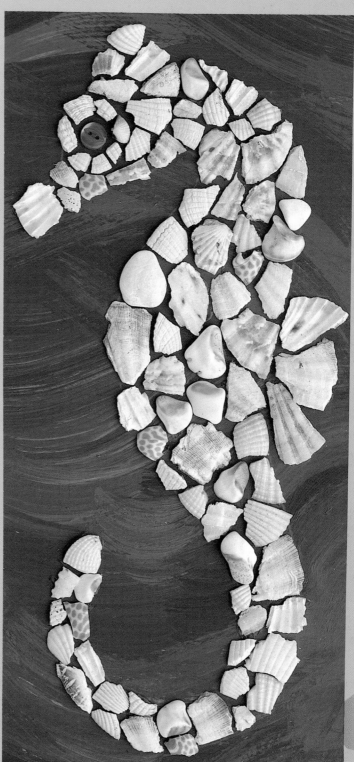

Crazy paving crab

You only need to use two colours to make a picture with a background. Fill in a simple animal shape with irregular shaped pieces using a wonderfully wild mosaic technique.

YOU WILL NEED

- **A sheet of white card the size of this page**
- **Old glossy magazines**
- **Scissors**
- **PVA glue and small plastic spreader**
- **Pencil and rubber**

1 Trace the crab template on p. 39 onto the sheet of card (see p. 6).

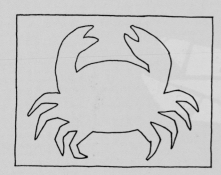

2 Cut out blocks of turquoise and orange from the magazines. Try and find different textures within the colours (shiny, rough, patterned, or even colours which have writing on) to make your mosaic look lively and exciting.

3 Cut the blocks of colour into triangles, squares, rectangles, and every shape in between, by holding the paper and cutting off pieces randomly. The pieces need to be different shapes and sizes but no bigger than about 3cm square. Start by making about fifty of each colour – you can always make more if you need to.

4 Do the crab first. Start by sticking pieces of paper at the ends of the legs and move towards the body. Don't worry if you go over the pencil outline, but don't give your crab an extra leg by mistake!

5 Once the legs are done, move on to the body, working from the outside and moving in. Try to keep the gaps between each piece as small as possible, although they will vary as you are using irregular pieces.

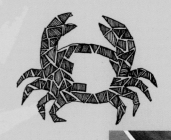

This style is very similar to the way in which the Spanish artist and architect ANTONI GAUDI worked. He had ceramic tiles with beautiful patterns made especially for him and then broke them up and used them for mosaic. He used this technique to cover the inside and outside of the houses he designed. He also designed an entire park in Barcelona called Parc Guell that features mosaic benches as well as a huge dragon sitting on a staircase.

6 As you reach the centre of the body, you may have to cut special shapes to fit into the small spaces left. Pick a piece that looks as if it will almost match, then trim it to fit. Continue until the animal shape is complete.

7 Now move on to the background. Do the area next to the crab first, using small pieces for the spaces between the legs, and move outwards. When you reach the edge of the card, don't go right up to it but leave a small border of about 3mm.

8 Rub out any pencil lines that are showing and re-stick any loose corners that may have come up.

9 Try making another animal shape, like the scorpion on p. 40, or design one of your own!

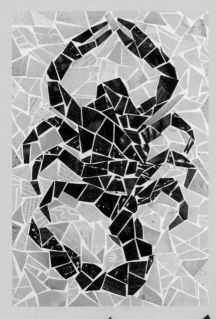

13

Animal bookmarks

Design and create your own animal bookmark using mosaic squares in two or three colours. Use other types of coloured paper for different effects.

YOU WILL NEED

- A sheet of thin coloured card (choose a colour you're not using for the squares)
- Coloured paper (plain-coloured paper, fluorescent or handmade paper)
- Scissors
- PVA glue and small plastic spreader
- Ruler
- Pencil and rubber

1 Using a ruler and pencil, draw out a 21 x 8cm rectangle lightly on the card.

2 Decide on an animal (or anything you like!) which has a nice long shape and will fit into the rectangle. Practise drawing it on a rough piece of paper. If you make parts of the animal break out of the shape, it will make it look much more exciting! When you are happy with your design, draw it in the rectangle with a pencil.

3 Choose two or three colours for your animal. Cut the paper into strips about 5mm wide and then cut them into squares.

4 Start by filling in the animal shape. Starting from the outside, stick the pieces in a continuous line and move in. The aim of mosaic is to get a sense of flowing lines, so when you come to a bend or a corner, cut the square into whatever shape you need to fit, so that your line can continue smoothly. As you move inwards and the spaces become smaller, you will need to do this more often. Continue until the animal shape is complete.

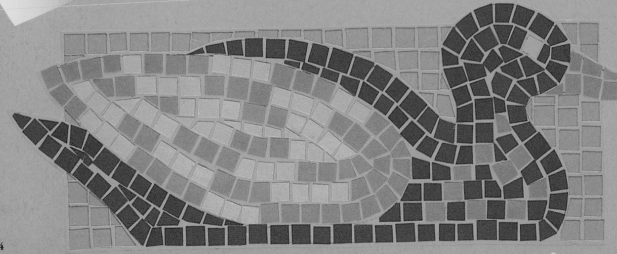

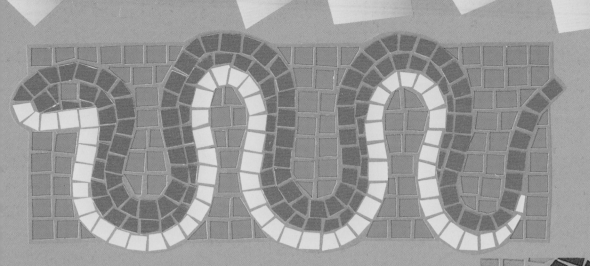

5 Now choose a different colour for the background and cut out squares as before.

6 To contrast with the flowing lines of your animal, stick the squares on the background in horizontal lines, moving inwards from the outside edges. When you come to the edge of your animal shape, cut a square to fit into the space, then carry on with the next line.

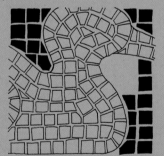

7 When your mosaic is completely finished and you have rubbed out any pencil lines that are showing, carefully cut out your bookmark leaving a small border around the edge.

8 Make lots more bookmarks with different designs. They make great presents!

TIP

Make patterns on your animal by sticking down different coloured squares every so often to make stripes or spots. Don't forget to include a different coloured square for the eye.

Sparkly flower frame

Decorate a flower-shaped frame with a glittering mosaic of sequins and buttons.

YOU WILL NEED

- **A sheet of yellow card at least 25 x 50cm**
- **Flat buttons in pink, red and yellow**
- **Sequins in gold, silver and pink. Try to find holographic, ones and shell and heart-shaped ones if possible.**
- **Scissors**
- **Pencil and rubber**
- **PVA glue and small plastic spreader**
- **Double-sided tape**
- **Compass, protractor and ruler**

1 Use the compass to draw a 10cm diameter circle inside a 24cm diameter circle (compass arms should be 5cm and 12cm apart respectively) on one half of the yellow card.

2 Use a protractor to mark off eight 45-degree angles on the inner circle and extend the lines out to the edge of the outer circle with a ruler. This will make eight petals for your flower.

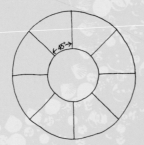

3 Make the segments into petals by drawing semicircles at the ends, then cut out the flower shape. You will need to cut out the middle circle as well. Use sharp scissors to make a hole first, then cut out the inside of the circle (ask a grown up to help you with this).

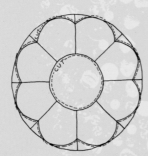

4 Turn the frame over, so that you are working on the side without the pencil lines. Arrange the buttons and sequins on the flower. Place them in rings starting from the outside and working inwards. If you have mixed or odd buttons, it might be easier to design each petal individually.

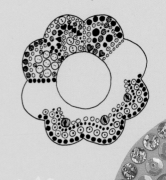

5 When you are happy with your design, leave the pieces where they are and start sticking each one down. This way you make sure that everything is in the right place and that it all fits together properly.

6 Work from the outside and move in, but if you have designed a border around the inside of the frame, do it first or you might run out of room!

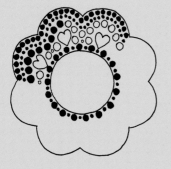

7 Towards the centre, you will probably need to leave bigger gaps between the pieces. Don't worry about it, just try to incorporate them into the design!

8 When the frame is finished, leave flat for a few hours until the glue has completely dried.

9 Place the frame on top of the other half of the yellow card, and use it as a template to make the back of the frame. Draw round it and mark one petal on both pieces so you can get a perfect match when you stick them together. Cut it out (but remember, you don't need a hole in this piece).

10 Put little strips of double-sided tape on the inside of the frame on the edges of six petals (leave two unstuck to give you room to slide in a photograph) and stick the two pieces of the frame together.

11 Choose a photo that fits the size of the frame. Put a piece of double-sided tape on the back to keep it firmly in place, then slide it in.

12 Try making different shaped frames in the same way. You can make a heart shape in red and pink, or a shell shape decorated with tiny shells.

Pretty picture frames

Make a rectangular frame in brightly coloured geometric designs inspired by ethnic patterns.

MOROCCAN FRAME

YOU WILL NEED

- **A sheet of plain card**
- **Dark blue, bright yellow and brown coloured paper**
- **Patterned paper (wrapping paper, wallpaper or old glossy magazines) in turquoise blue. Paint some pale patterned paper with ink if you can't find any in the right colour. Use ink rather than paint so that the pattern will show through.**
- **Very sharp hard pencil**
- **Scissors**
- **Small sharp scissors**
- **PVA glue and small plastic spreader**
- **Ruler**
- **Double-sided tape**

1 Photocopy the Moroccan frame template on p. 41 and stick it onto the piece of card, but don't cut out the frame just yet.

2 Using the small scissors, very carefully cut out the star, square and rectangle at the bottom of the template. Stick them onto a piece of card and cut them out as accurately as you can, as these are the templates for your tiles.

3 Draw round the shapes on the coloured paper. Keep sharpening your pencil so that the lines are as clear as possible. Cut out the shapes using the small scissors. You will need 14 yellow stars, 14 brown stars, 56 dark blue rectangles and 28 turquoise squares. This is going to take some time, but persevere – it will be worth it! Maybe you can ask a patient friend or parent to help you out!

4 Take four of the brown stars and mark them into quarters using a ruler and pencil. Cut out one quarter from each star. These quarters will go on the outside corners of the frame while the remaining three-quarters will go on the inside corners. Cut the rest of the brown stars into halves.

5 Cut 14 of the turquoise squares diagonally in half to make 28 triangles.

6 When all the shapes are cut out, start sticking them over the corresponding shapes marked on the frame. Begin at a top corner and work round, always sticking one tile next to another. Don't panic if they don't interlock perfectly – neither do real Moroccan mosaic tiles!

7 When your mosaic is finished, cut round the outside of the frame, leaving a border of 2-3mm. It doesn't need to be completely straight. Cut out the middle of the frame in the same way as described in the flower frame project (p.16).

8 Use the frame as a template to make the back of the frame from another piece of card. Use strips of double-sided tape to join the two halves of the frame on three sides. Leave the top unstuck to slide in your photo or picture.

The term for the Moroccan style of mosaic is ZILIJ. It is made from tiles in specially cut shapes such as stars, hexagons, triangles, diamonds and other geometric shapes. The tiles are all given special names and they fit together in a variety of patterns, which must be learned by the craftsmen who make them. They are used to decorate walls and floors in buildings and gardens.

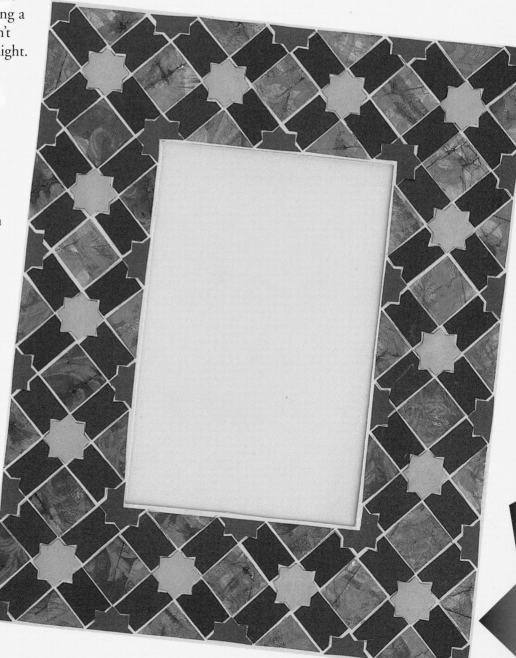

AFRICAN FRAME

YOU WILL NEED

- **A sheet of dark red card at least 24 x 38cm**
- **Orange, black and white paper**
- **Tracing paper**
- **Masking tape**

1 Trace the African frame template on p. 42 onto half of the sheet of card (see p. 6).

2 Cut the black and orange paper into strips just under 1cm wide and then cut them into squares. You will need 28 black squares and lots of orange ones.

3 Cut the white paper into strips of about 3-4mm wide from the white paper and then cut them into squares.

4 Mark four of the black squares diagonally into quarters, then cut one quarter from each as you did with the stars in the Moroccan frame. Cut ten more black squares diagonally in half to make 20 triangles. Cut 27 orange squares in the same way to make 54 triangles. These will go along the edges of the frame.

5 Stick the black tiles down first to create the centre of each diamond shape. Next, stick the orange tiles around them, using eight orange squares to surround each black one. Where the diamond pattern meets the edge of the frame, use the triangle shapes to fill in the spaces.

6 Fill in the lines around your diamond shapes using the white squares (or leave them blank if it is too fiddly).

7 When your design is finished, cut round it and put together in the same way as the Moroccan frame.

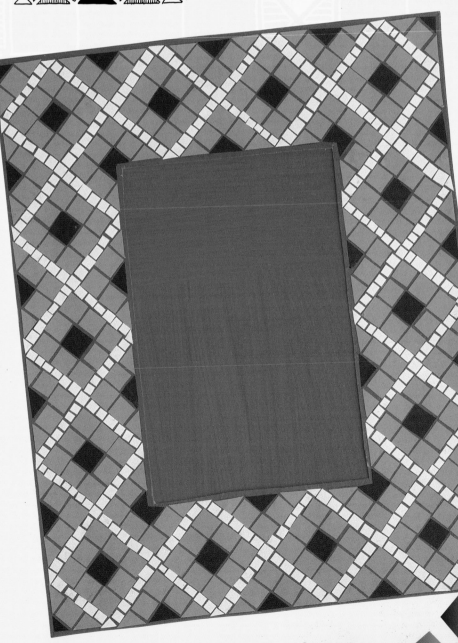

20

AMERICAN PATCHWORK FRAME

YOU WILL NEED

- **A sheet of card**
- **Old glossy magazines, wrapping paper or wallpaper**

1 Photocopy the American patchwork frame template on p. 43 and stick it onto half of the sheet of card.

2 Choose a colour scheme for your frame and cut out blocks of patterned paper. You are aiming for a patchwork quilt effect made out of lots of scraps of fabric, so choose lots of different patterns.

3 Cut the paper into squares that are smaller than the squares on the design.

4 Make the triangles by cutting the squares diagonally in half and then half again.

5 Fill in the design using colour and pattern randomly. For variety, substitute bigger 'half' triangles for the smaller 'quarter' ones.

6 Cut out and put together as the other frames.

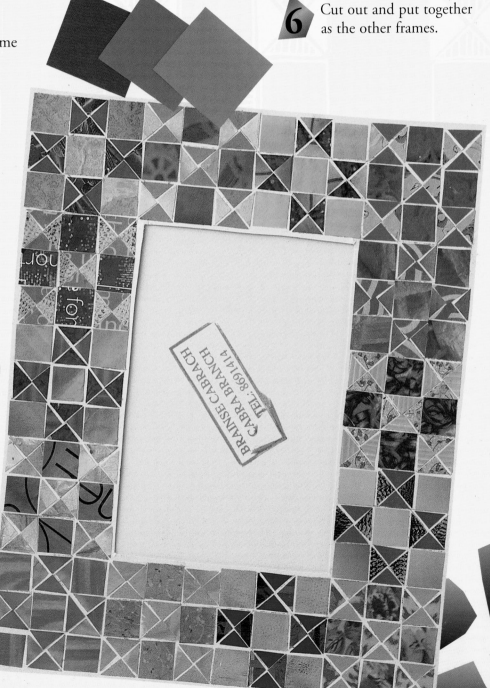

Stained glass window sticker

Create a stunning starfish sticker for a window using pieces of coloured cellophane to give a stained glass effect.

YOU WILL NEED
- **A sheet of white paper**
- **Clear sticky-back plastic (available from stationers)**
- **Cellophane, coloured acetate or cellophane sweet wrappers in orange and light blue or green**
- **Pencil**
- **Two black felt-tip pens, one thick and one thin**
- **Scissors**
- **Masking tape**
- **Compass or small plate (about 20cm diameter)**
- **PVA glue and small plastic spreader**

1 Draw a 20cm circle on the white paper using the compass or plate.

2 Draw a chunky starfish shape in the circle, making sure the ends of the legs touch the edges of the circle.

3 Go over the lines with the thin felt-tip pen. Draw lines going down the centre of each leg with the thick felt-tip pen.

4 Draw some thin lines between the legs of the starfish. These will act as a guide for placing your mosaic pieces.

5 Cut a piece of the sticky-back plastic slightly bigger than the circle. Tape it (paper side down, shiny side up) to your drawing using little strips of masking tape. You should be able to see your drawing through the sheet of film.

6 Cut the orange cellophane into strips about 1.5cm wide. Cellophane is a floppy material to work with, so cut each strip into smaller strips about 4cm long.

7 Start at the top of each starfish leg and work down, doing one half at a time. Cut a triangle to fit the top of the leg and stick it down, leaving a gap where the thick centre line is. Cut the pieces to fit the spaces. Do this by eye if you feel confident! If not, then lay each cellophane strip over the area you are filling, mark the lines with the thin felt-tip pen and cut it out.

8 As you get nearer to the bottom, use the lines you drew in step four as a guide to cutting the right shapes for the spaces. You will need to cut angled or triangular pieces to do this.

9 Do the other half of the leg in the same way, then work round the rest of the starfish.

10 Cut out strips of just over 1cm wide from the blue or green cellophane and cut them into squares. Fill in the background starting at the outside of the circle and moving in. As you get further in, cut the squares to fit round the curve. Cut out whatever shape you need to fit in at the bottom.

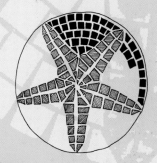

11 Leave to dry. The glue is dry when it becomes transparent. This may take a couple of days as it is sandwiched between two pieces of plastic. When this is done, cut another piece of plastic roughly the same size as your original. Peel off the backing paper and stick it carefully over your cellophane mosaic.

12 Cut out the mosaic circle with the scissors, peel off the backing paper and then stick it onto a window where the sun can shine through it.

Shiny fish mask

Show off your mosaic skills with this eye-catching fish mask. Holographic and shiny coloured papers make it shimmer when it catches the light!

YOU WILL NEED

- A sheet of thin card
- Tracing paper
- Silver holographic paper
- Blue and green shiny holographic paper
- Turquoise ink or acrylic paint
- Small scissors
- PVA glue and small plastic spreader
- Piece of thin elastic
- Two small silvery beads (optional)
- Strong, sharp needle

1 Trace the fish mask template on p. 44 onto the sheet of card (see p. 6). Cut it out and use small scissors to cut out the eye holes.

2 Paint the front of the mask with ink or paint, but mix it first with water so that you can still see the lines through it.

3 Cut the blue paper into strips about 5mm wide and cut out little rectangles with slanted sides.

4 Stick the rectangles around the eyes putting the widest edge against the widest part of the circle.

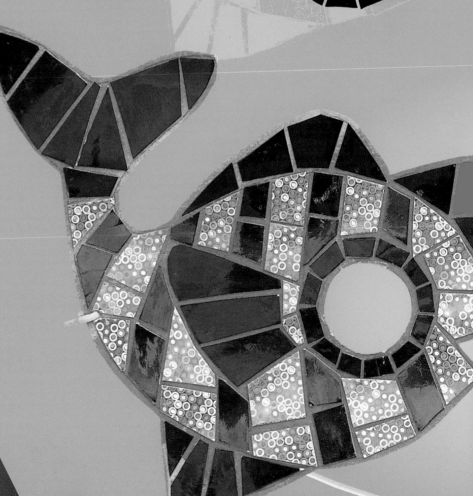

24

5 This time, instead of filling the spaces with lots of squares, you must cut shapes to fit the spaces. Start with the fin next to the eyes. Cut a long thin wedge shape in the blue paper, then lay it over the fin and mark with a pencil the places where you need to cut so that it fits perfectly.

6 Do alternate green and silver stripes in the same way, using squares or rectangles cut to fit. Start with the head, using silver, and work across.

7 When the body is finished, do the outside fins and the tail with blue paper.

8 Repeat steps four to seven on the other side. When both fish are complete, do the bridge across the nose in horizontal lines of green.

9 Leave the mask to dry for a couple of hours under a heavy weight, like a pile of books, to stop it curling up.

10 Pierce a hole in either side of the mask, between the fish's bottom fin and tail, using the needle (ask a grown up to help you with this).

11 Measure a piece of elastic that will hold the mask firmly on your head. Thread one of the beads on the elastic and tie it on securely. Thread the elastic through the front of one of the holes, so the bead is visible at the front of the mask. Now thread the elastic through the back of the other hole and tie a bead on the other end, so the bead is visible on the other side (fig a). If you don't have any beads, just thread the elastic through the holes and tie the ends (fig b).

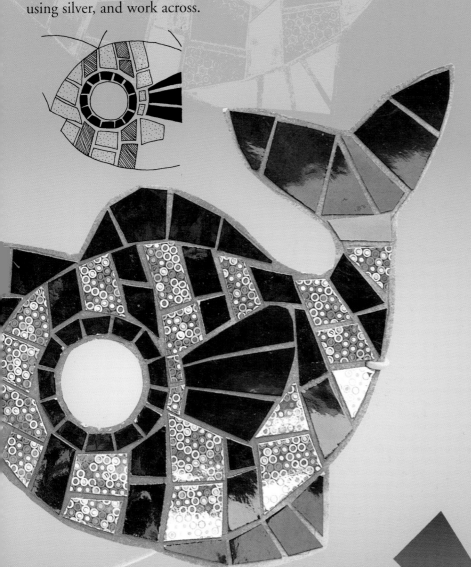

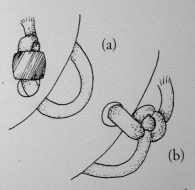

(a)

(b)

Ripped paper picture

Ripping the paper gives a much softer effect. Use this new technique to make a spotty giraffe in a bright sunny African landscape.

YOU WILL NEED
- A sheet of dark brown card
- A sheet of cream-coloured paper
- Coloured paper in two shades of blue, three shades of brown, some orange, yellow, black and lots of greens
- PVA glue and small plastic spreader
- Pencil

1 On a photocopier enlarge the template of the giraffe on p. 45 and trace it onto the cream-coloured paper (see p. 6). Then, using small tearing movements with your forefinger and thumb as you follow the outline round, tear out the giraffe and stick it onto the brown card.

2 Draw the background. Create an African landscape with grass, trees and distant mountains.

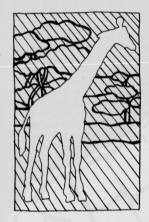

3 Start ripping some pieces from the brown paper for the giraffe's body. Do it in the same way as you did when you were using scissors – by making strips and then squares – but as you are not using scissors, you will get pieces of many different shapes.

4 Begin by sticking the pieces on the giraffe's body, working from the head and moving downwards. Use smaller pieces on the head, not forgetting an eye, then make the pieces bigger as you work down the body. This technique should make the giraffe's spots look realistic.

5 Use smaller pieces to do the legs, and as you go down start to use orange or light brown pieces. Do the hooves with black pieces ripped to the correct shape.

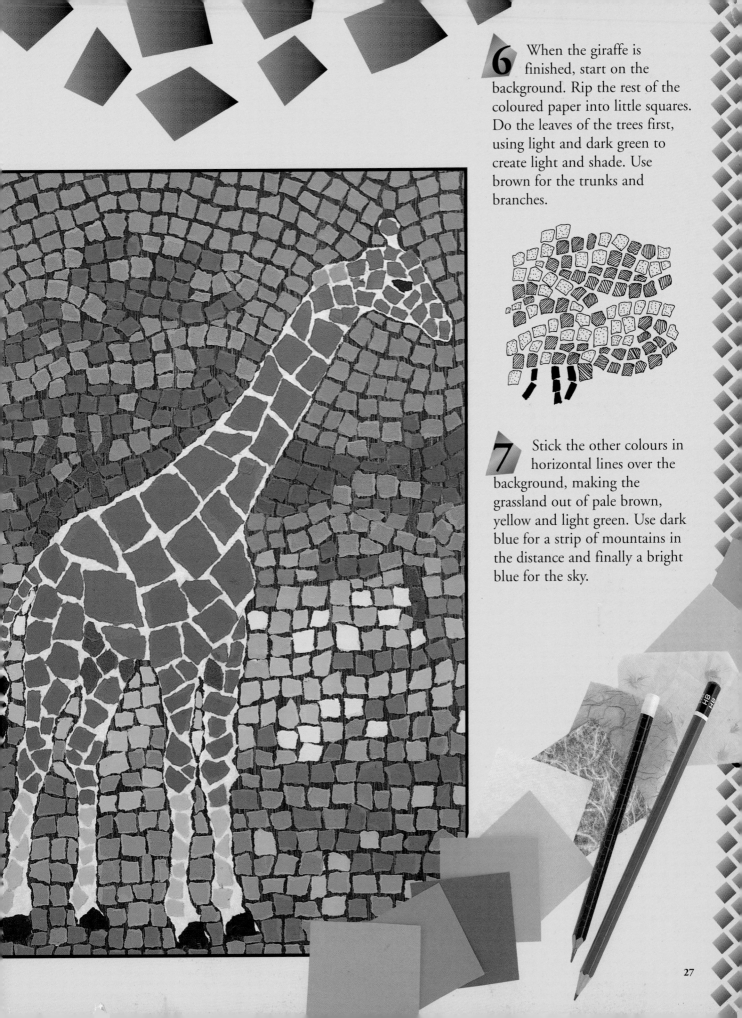

6 When the giraffe is finished, start on the background. Rip the rest of the coloured paper into little squares. Do the leaves of the trees first, using light and dark green to create light and shade. Use brown for the trunks and branches.

7 Stick the other colours in horizontal lines over the background, making the grassland out of pale brown, yellow and light green. Use dark blue for a strip of mountains in the distance and finally a bright blue for the sky.

Fantastic fish mobile

Turn your room into a colourful ocean scene with this fabulous fish mobile. Use tiny circles in coloured paper to create the effect of shimmering scales on a shoal of brightly patterned tropical fish.

YOU WILL NEED

- A sheet of coloured card
- Tracing paper
- Coloured paper in lots of bright colours
- Silver, gold and coloured foil (or foil sweet wrappers)
- Hole puncher
- PVA glue and small plastic spreader
- Scissors
- Cotton thread or thin wool
- Strong needle
- Drawing pins or Blu-tac

1 Choose one of the fish templates on p.46 and 47. Trace around it onto the sheet of card (see p. 6).

2 Lightly pencil in the details such as the eye, the fin and the pattern.

3 Decide on the colours you want your fish to be and use the hole puncher to make lots of circles from the coloured paper and foil. Do each colour separately. Remove the circles from the little plastic tray underneath the hole puncher and store them in old lids or little pots, keeping each colour separate.

4 Start by filling in the eye and the side fin. Make the fish's eye by first sticking down a large black circle, then a smaller circle in another colour and finally a smaller black circle on top of each other. See the tip box for the different ways to make the fins.

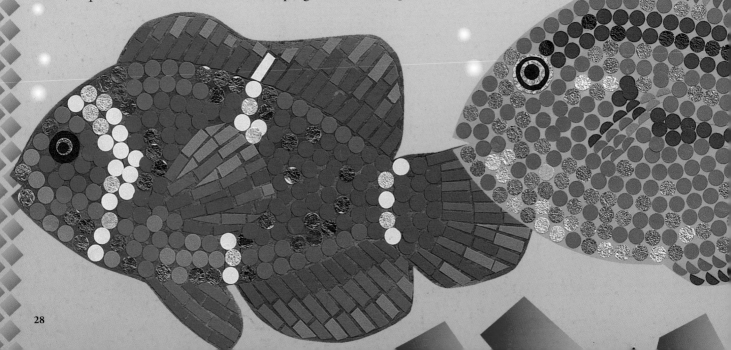

5 Make the body of the fish by starting at the mouth and sticking circles round the outside. Change colour when you come to a line indicating a new pattern. Don't forget to use foil circles occasionally to make your fish sparkle.

6 Continue working inwards in the same way, starting and finishing each line at the mouth, until the whole body is filled. If a circle is too big to fit into a space, just overlap the ones around it. Continue until the fish body is complete.

11 Using the other templates, make lots more fish in different patterns and colours. You can try drawing some of your own, too! Vary the lengths of thread for each fish so they hang at different heights. You could also make whales, seahorses and starfish if you like.

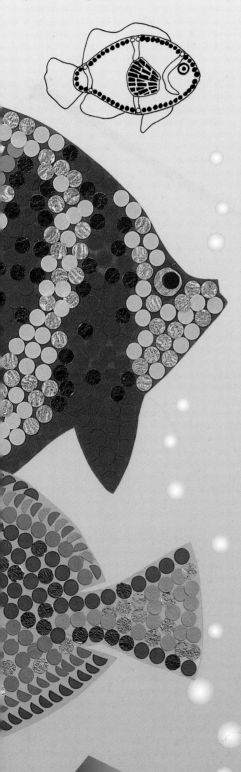

7 Fill in the top and bottom fins and the tail using one of the methods described in the tip box.

8 When one side of the fish is finished, cut it out leaving a border of about 2-3mm. Turn the fish over and do the other side. You can use the same colours and patterns, or design new ones.

9 To attach a string to the fish so that it can hang from the ceiling, pierce a hole at the top using a strong, sharp needle (ask a grown up to help). Hold the top of the fish lightly between your thumb and forefinger and decide on the angle you like best, and then make a hole where your fingers were.

10 Thread a piece of cotton or thin wool through the hole and tie a small loop in it. Stick it to the ceiling with drawing pins or Blu-tac.

YOU CAN MAKE THE FINS AND TAIL IN THREE WAYS:

1 Use circles as you do on the body, but use different colours so they really stand out.

2 Cut the circles in half and arrange them in lines, diagonally for the top and bottom fins, and in a fan shape for the body fin and tail.

3 Use tiny strips of paper in the same way as example two. For the top and bottom fins, cut the first strip nearest the fish's body with a diagonal end so they radiate out at an angle. Cut long thin triangles to fill in the gaps on the body fin and tail.

Decorated jungle box

A sumptuous design of lush jungle leaves revealing glimpses of colourful animals turns an old shoebox into a treasure chest.

YOU WILL NEED

- **Shoebox (preferably white) with lid**
- **Coloured paper in lots of different colours**
- **Dark blue acrylic paint (or waterproof ink) and a thick brush**
- **Plain white paper**
- **PVA glue and small plastic spreader**
- **Scissors**
- **Pencil and paper**
- **Light-coloured pencil**
- **Sticky-back paper (holographic if possible)**

1 Prepare your shoebox and lid by gluing strips of white paper over any joins on the corners. You need to create a smooth flat surface for the mosaic and provide a clear background for the paint.

2 Paint the outside of the box with the paint or ink. Take the paint just over the insides of the box and lid, too. Leave to dry.

3 On a spare piece of paper, practise drawing different animal heads and leaf designs. You can get ideas from books, but try and make them a good size and keep them quite simple. Draw some leaves over the animal faces, so they look as if they are peeping out of a jungle. Think about where your designs will fit best. Use smaller shapes on the sides and bigger ones for the lid. Plan the colours so that you don't get the same ones next to each other.

4 Draw your finished design over the box and lid using a light-coloured pencil. If you're feeling clever, put the lid on the box and draw the design so that it flows continuously over the box and lid. If not, draw out separate designs and leave a space round the edge of the lid for a border pattern (see tip box). Remember that the lid will cover the top of the sides of the box, so don't draw too much detail there!

TIP

If you are not joining your images up on the box and lid, decorate the edges of the lid with a simple pattern using two shades of green. Try one of the ones shown or make up one of your own.

5 As with all the projects, do the foreground first, using lighter greens for the foreground leaves and bright colours for the animals. Darker greens will be better in the background to give depth.

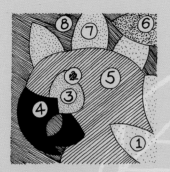

6 When you have finished your mosaic, varnish it by painting on a mixture of PVA and water. This is white until it dries and will make the colours look deeper and richer. It will give your box a lovely shine, as well as making it stronger. Hang the box and lid separately over a couple of tall jars so they can dry without sticking to the table. (Don't forget to put down newspaper to catch the drips.)

7 When the PVA varnish has dried, decorate the bottom and the inside of the box and lid. Cut some sticky-back paper into small pieces and make a collage with them so there are no gaps showing. If you can't find this type of paper, use any kind of shiny green paper (or even sweet wrappers) and stick them down using PVA.

MAKING LEAVES

1 Use little squares to make clusters of leaves. Starting with a square at the top corner work round, then move in.

2 Use little strips to make long thin leaves or trailing vines. Start with the outside edges and work inwards, cutting the strips as you need to.

3 Make big leaves for the background using big squares. Give some of the leaves holes, so the background colour shows through. Lay squares around the outside of the holes as well as the outside of the leaves and fill the spaces in between in whatever way seems most natural!

4 Make leaf stems with a line of thin strips or rectangles.

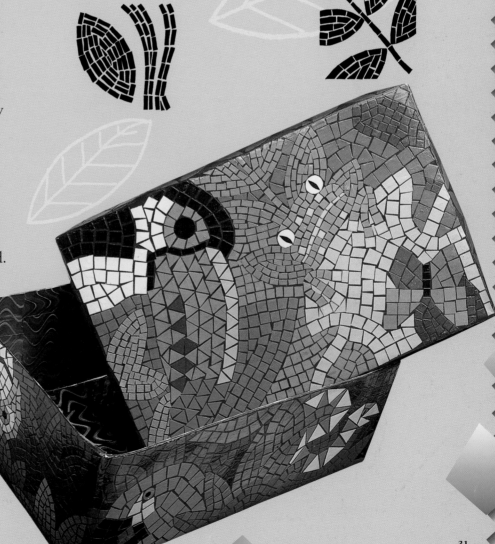

31

MAKING A TOUCAN

1 Cut a big black circle for the eye, stick it down and surround it with a ring of green squares trimmed to form a smooth circle.

2 Use big squares for the head and strips of different colours, as in the photograph, for the toucan's brilliant beak. Cut the strips into triangles and lay them along the beak, starting at the top. As you reach the bottom, you might have to cut the triangles thinner and flatter to fit.

MAKING A LEOPARD

1 Cut two small black circles for the centre of the eyes and lay a ring of small green squares around them. Make one or two of the squares lighter in each eye to make highlights. Cut two squares into two triangles and lay them at either corner of the eyes.

2 Make the nose by cutting a big square into two triangles and placing them back to back. Use lines of black strips for the whiskers with white strips cut to fill the gaps.

3 Make the ears using a combination of brown squares and triangles and surround them with pink squares which have been cut to fit.

4 Cut out some different sized black circles and lay them randomly around the head. Cut out some small orange squares and work them in around the circles. Start each line from a different point at the bottom of the cheeks to make them appear fluffy.

MAKING AN IGUANA

1 Cut out different shades of bluey-green and yellow circles using a hole puncher. Cut out a small black circle for the eye and lay long thin triangles of blue all around it.

2 Cut out some more circles in the same shade of blue and cut them in half. Lay them in a line to make the iguana's mouth. Fill in the rest of the body using the bluey-green circles, occasionally dropping in the odd darker, lighter or yellow one.

3 Cut out some light yellow triangles to make spines for the iguana's back.

MAKING A SNAKE

1 Cut out a green circle for the eye and lay a thin black 'petal' shape on top of it to make the snake's slitty pupil. Cut strips the same width as your snake's body from yellow and pink paper. Cut them as you did for the toucan's beak, but vary them so you get some fat triangles and some thin ones.

2 Stick triangles of alternate colours to fill the snake's body. The fat triangles should go on the fattest part of the snake's curves, so as the curves of your snake change direction, you will have to change the size of the triangles.

3 Make the head by snipping big shapes to fit inside your outline.

MAKING A BUTTERFLY

1 Cut out big squares in similar shades of blue. Starting with the top wings, lay a square on the outside of the bottom line and work inwards, trimming the squares to fit as necessary. Then do the next line up, starting with a full square on the outer edge.

2 Lay the squares for the bottom wings on their points so they look like diamonds. Start with the bottom 'point' and work inwards and upwards as before.
Make the butterfly's thin body and head using small black squares.

Magnificent mosaic mermaid

Use all of your newly-acquired skills and a variety of materials to create a mosaic picture of a beautiful mermaid surrounded by shimmering fish and waving seaweed fronds.

YOU WILL NEED

- **A large sheet of thick card, painted turquoise green**
- **Tracing paper**
- **Coloured paper**
- **Shiny foil paper or holographic paper**
- **Old glossy magazines**
- **Blue, silver and green circular sequins, plus iridescent or holographic ones, if possible**
- **Star or shell-shaped sequins or real shells**
- **Dried pulses – brown lentils, split peas, small light-coloured beans**
- **Transparent glass nuggets**
- **Hole puncher**
- **Scissors**
- **PVA glue and small plastic spreader**

1 You need paper in four different shades of blue for the sea, so you may have to paint some white paper. Make turquoise by adding bright green to bright blue, then slowly darken it using a darker blue. Use a separate piece of paper for each shade.

2 Go through the glossy magazines and cut out pieces of bright orange, lime green, purple and big chunks of blonde hair.

3 On a photocopier, enlarge the mermaid template on p. 48 and trace it onto the turquoise card (see p. 6).

4 Around the mermaid, draw thin branches of seaweed growing out of a rock. Now draw a shoal of fish swimming diagonally across the picture. If you do them quite big, they will look as if they're at the front of the scene.

5 When you have completed your drawing, arrange a few of the glass nuggets over it, so they look like bubbles. Stick them down.

6 Arrange and then stick down any star or shell sequins (or shells) you are using. You could put them on the sandy sea bottom and the rock, or even over the mermaid's hair.

7 Make the fish out of orange paper cut from the magazines. Cut squares that will be wide enough to cover the fish in just a few rows. Start at the mouth and work along the bottom towards the tail, then repeat along the top. Fill in the space in the middle with specially cut pieces. Make the tail out of triangles and use sequins for the eyes.

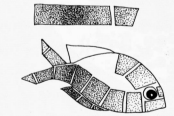

TIP
To make the bubbles look shiny, stick circles of silver foil (cut to the same size) to the base of the glass nuggets. Leave to dry for an hour or so and then stick them to your picture.

8 Make the seaweed from little strips of pink or lime green paper cut from magazines. Do the central stem first, followed by the branches.

9 Make the mermaid's glittering tail by cutting out lots of circles from the shiny foil with the hole puncher. Use silver, blue and green. Starting at the mermaid's waist, stick the circles and circular sequins in an uneven line from hip to hip and work downwards.

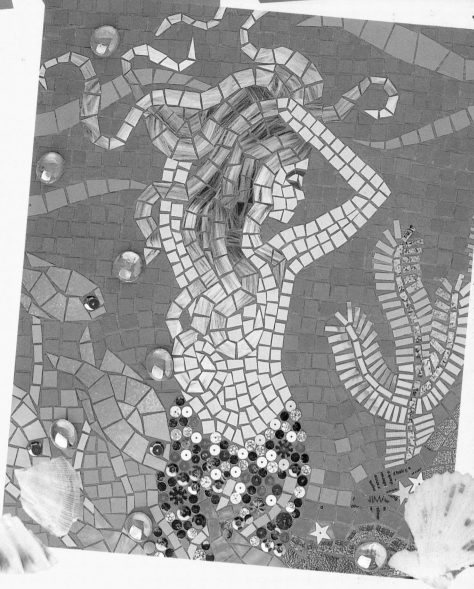

10 Stop sticking the circles just before the tail fin. Stick down five lines of dark blue paper strips on the fins. Then fill in the gaps with the colour you have been using for the rest of the tail.

11 Use chunks of blonde hair from magazines to make the mermaid's hair. Cut out squares of paper and stick them down, starting from the top, as you did for the fish. Cut smaller squares as the locks of hair get thinner, and shape them so they fit round the curls. Finish with a pointed triangle.

12 Cut a tiny triangle in dark blue for the mermaid's eyelashes, so it looks as if her eyes are closed. Make her eyebrow out of a couple of tiny strips in the same colour. Fill in the rest of the face and body using small squares of pale blue paper.

13 Make the rock out of squares of purple cut out from magazines. Use different shades of purple on different areas of the rock to create the illusion of shifting light.

14 Make the sandy bottom of the sea using a mixture of dried pulses. Place paler ones at the bottom and get darker towards the top. Spread the glue on small areas of the card, and stick the pulses directly onto it. Arrange them so that they flow around the mermaid, fish, rock and seaweed. Leave an uneven edge where they merge with the sea.

15 Do the water last. Cut small squares from the different shades of blue – only a few of the lighter ones, but a lot of the darkest shade. Start at the bottom on the 'rockless' side, sticking the squares in horizontal rows between the pulses, and work up, starting with the lightest blue and gradually getting darker.

16 It will take a bit of time to make your mermaid picture but it will be well worth the effort. All the different techniques and materials will combine to make a stunning picture and everyone will be impressed by your amazing mosaic!

TIP

To make a smooth colour change, include a couple of squares of the next colour on the last line of the one you are using. When you are working with the next colour, include a couple of squares of the previous colour on the first line.

TIP

Make swirly ripples on the surface of the sea by cutting out a wavy strip from one of the lighter blues and then cut and stick the squares down in the same order.

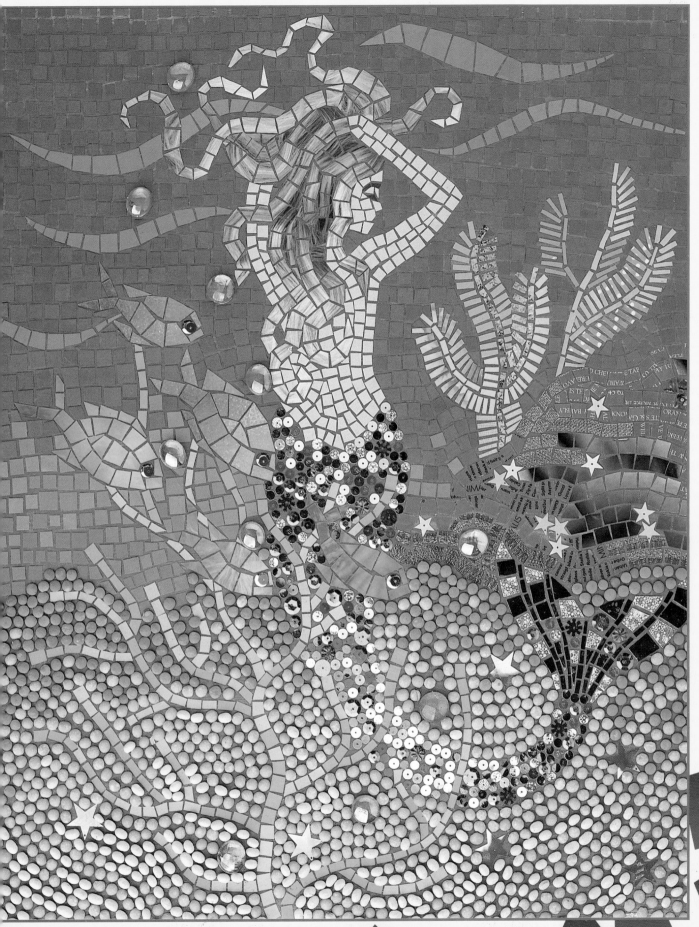

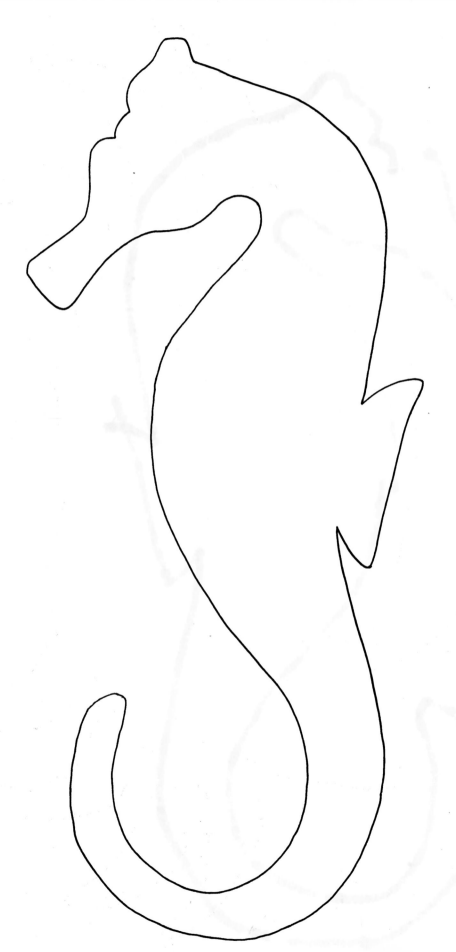

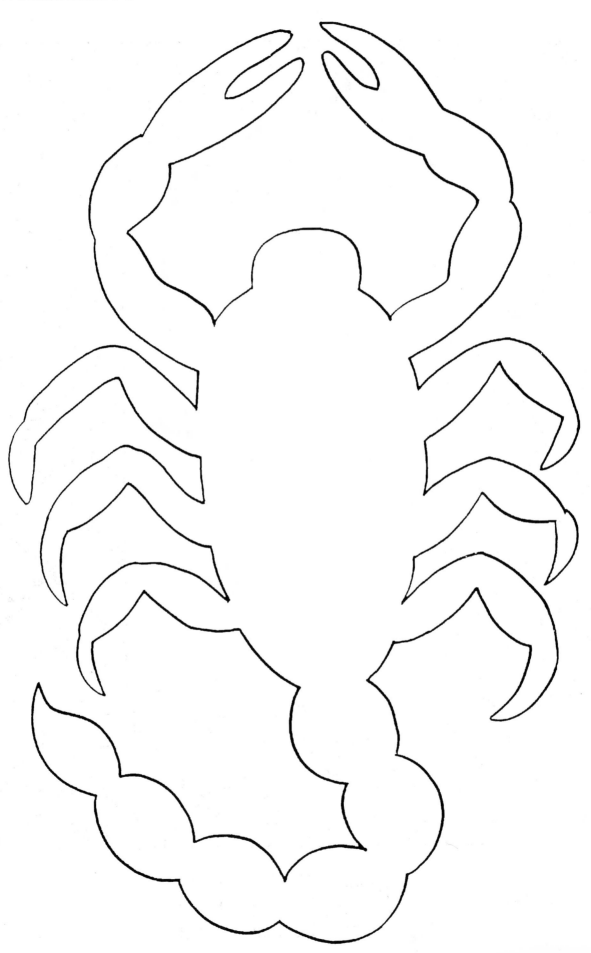

TILE TEMPLATES

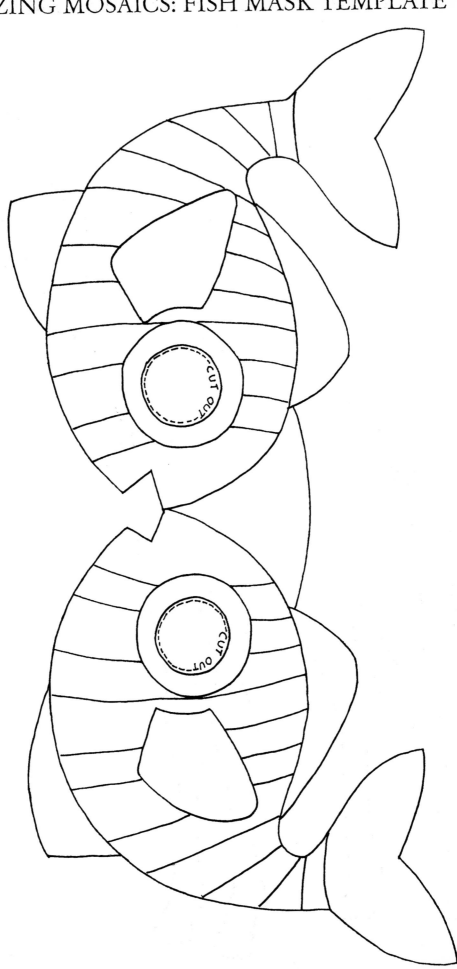

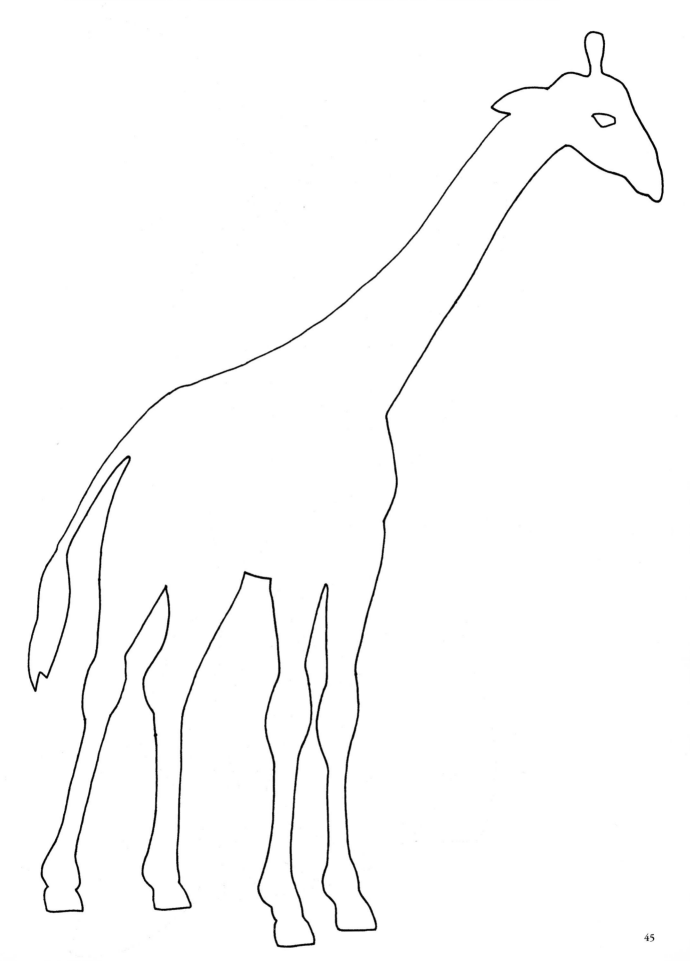

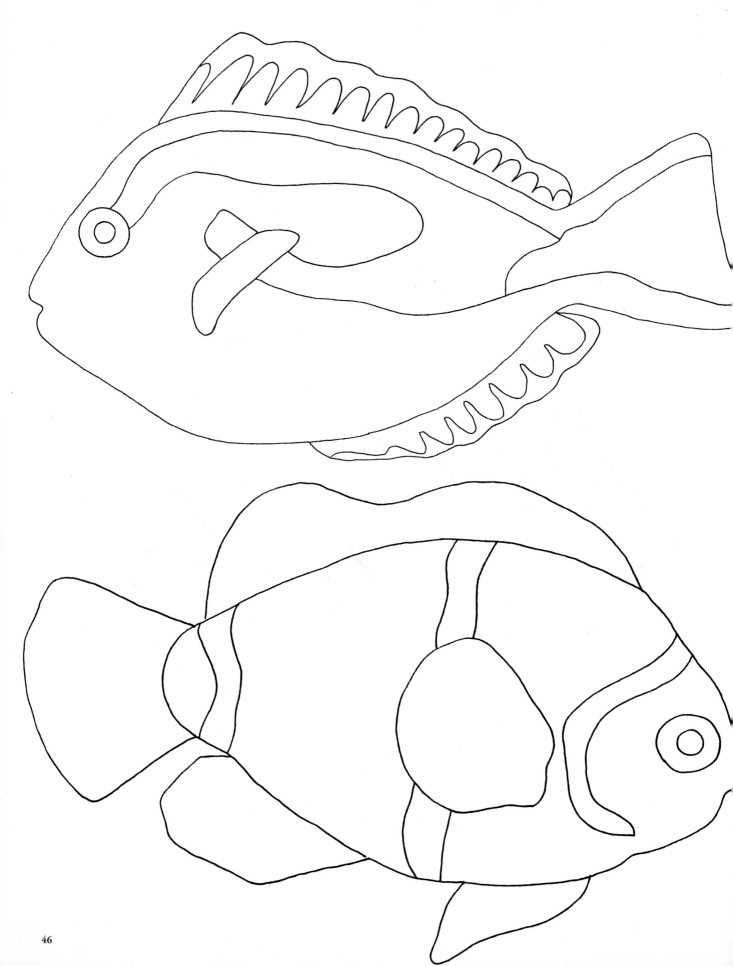

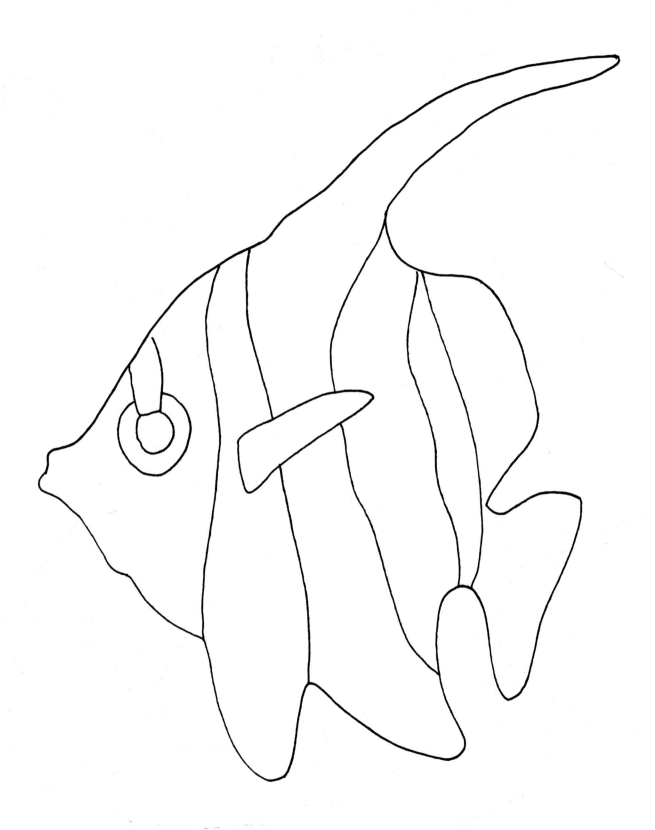

ACRYLIC FUSION

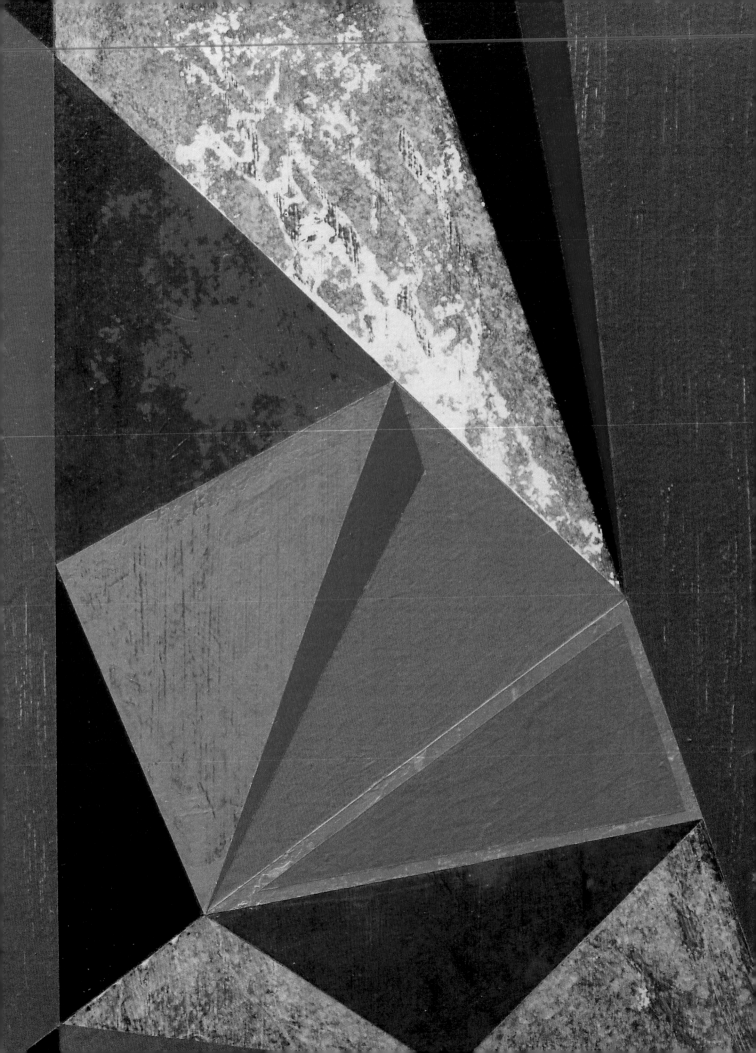

DAN TRANBERG

ACRYLIC FUSION

EXPERIMENTING WITH ALTERNATIVE METHODS FOR PAINTING, COLLAGE, AND MIXED MEDIA

Quarry Books
100 Cummings Center, Suite 406L
Beverly, MA 01915

quarrybooks.com • craftside.typepad.com

First published in the United States of America in 2012 by
Quarry Books, a member of
Quayside Publishing Group
100 Cummings Center
Suite 406-L
Beverly, Massachusetts 01915-6101
Telephone: (978) 282-9590
Fax: (978) 283-2742
www.quarrybooks.com
Visit www.Craftside.Typepad.com for a behind-the-scenes peek at our crafty world!

10 9 8 7 6 5 4 3 2 1

ISBN: 978-1-59253-752-5

Digital edition published in 2012
ISBN: 978-1-61058-186-8

Library of Congress Cataloging-in-Publication Data
Tranberg, Dan.
 Acrylic fusion : experimenting with alternative methods for painting, collage, and mixed media / Dan Tranberg.
 p. cm.
 ISBN-13: 978-1-59253-752-5 (pbk.)
 ISBN-10: 1-59253-752-9 ()
 1. Acrylic painting—Technique. 2. Decoration and ornament. I. Title.
 TT385.T726 2012
 751.4'26--dc23
 2011031314

Design: Rita Sowins / Sowins Design
Images: Dan Tranberg

Printed in Singapore

Golden Artist Colors, Inc. is in no way responsible for the contents of this book. The author does not work for Golden. As an artist, the author began using Golden products during the 1990s, and since that time, Golden has become his preferred brand of acrylic paint and media. With minor adjustments, the techniques in this book can be used with any brand of professional artist acrylics.

TO MY PARENTS.

CONTENTS

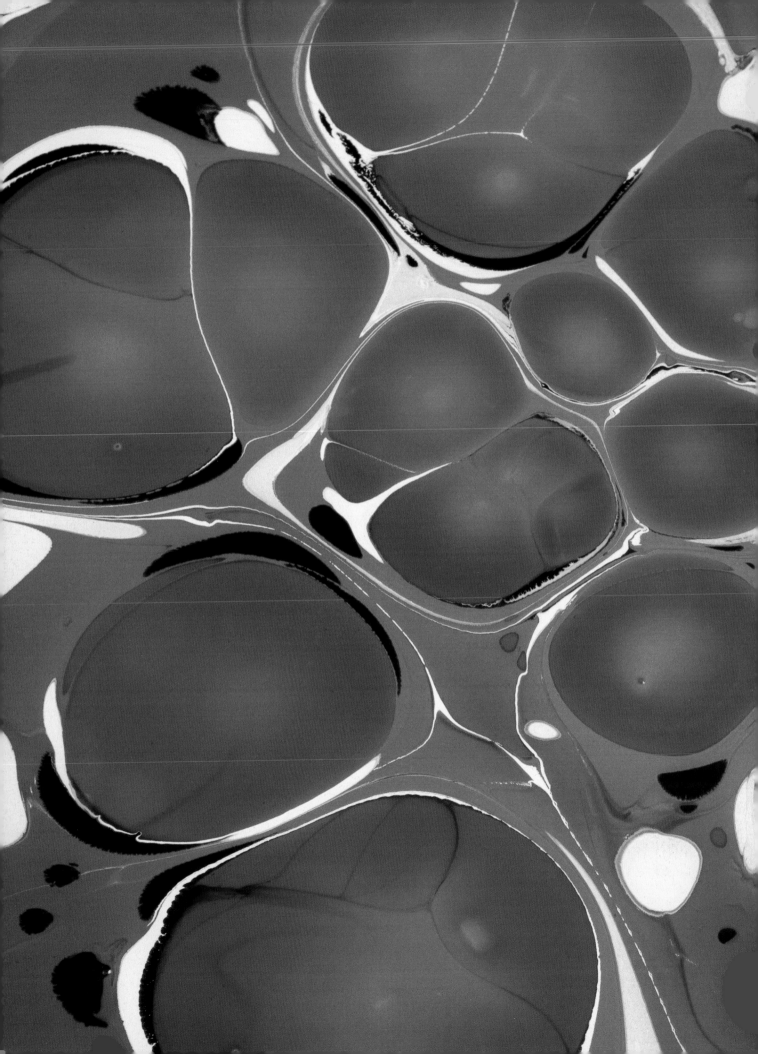

INTRODUCTION

Since the early 1960s, when acrylic paints formulated specifically for artists first became widely available, the medium of acrylic has grown to include an incredible diversity of products with a range of qualities unlike any other form of paint. In addition to the extensive range of acrylic colors now available, acrylic mediums have exponentially expanded the possible surfaces, textures, and applications now able to be achieved. More than ever, acrylic is a medium of endless possibilities.

This book was conceived as an introduction to the idea of experimenting with nontraditional approaches to acrylic paint. It uses abstract painting as a framework, but the techniques outlined here can be applied to many other outcomes, from journal making to furniture refinishing. It aims to expose some of the vast possibilities that acrylic paint holds, in hopes of sparking ideas, encouraging experimentation, and inspiring artists in many different creative endeavors. Learn more at www.acrylicfusionthebook.com.

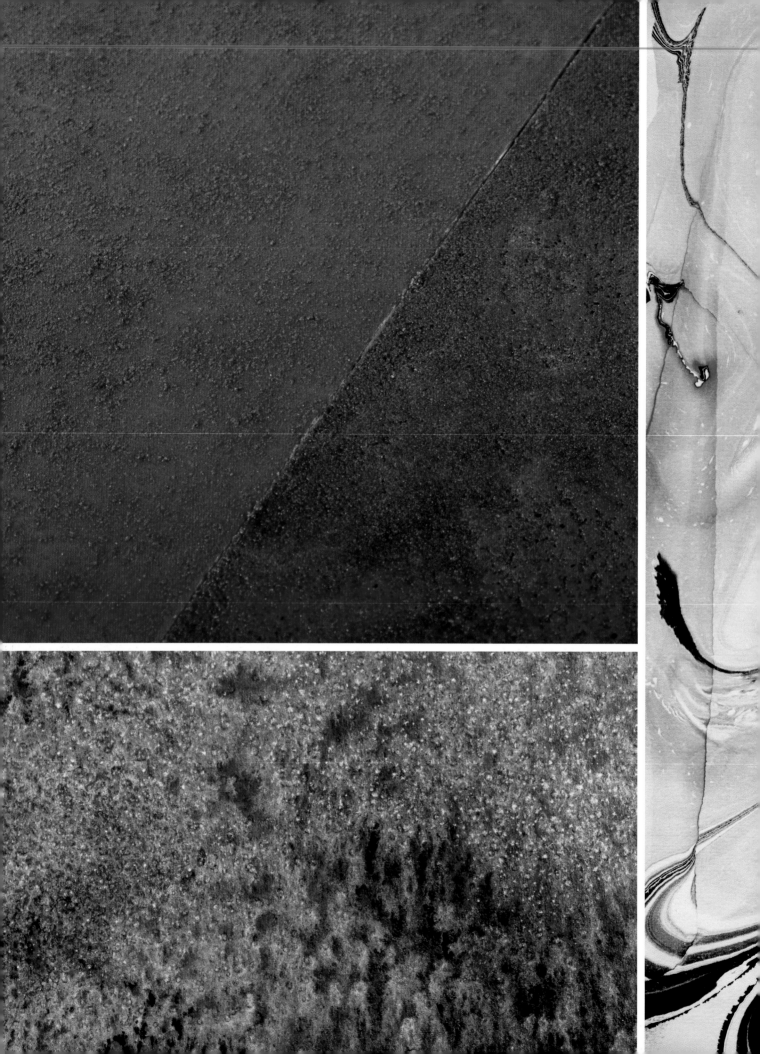

BASICS

The abstract expressionist painter Willem de Kooning once famously said, "Flesh is the reason oil paint was developed." So, what about acrylic paint? Just as the development of oil paint in the early fifteenth century changed the way that artists painted the human figure, the development of acrylic paint in the mid-twentieth century radically changed the way that paintings could be made.

No longer tied to the figure, or to realistic visions of the world, many of the artists who first used acrylic paint rejected centuries-old traditions and seized the opportunity to create bold and colorful abstract works that exploited the new medium's unique characteristics. Suddenly, large-scale works could be made relatively quickly; paint could be applied to raw canvas without fear of oil penetrating its fibers; and vast expanses of vivid color could be achieved with newfound ease.

Now, in the twenty-first century, acrylic paint is far more versatile than ever before. Testing the boundaries of its current potential begins with getting to know its many qualities. This introductory chapter outlines some basic information on materials, tools, and supports. Its goal is not so much to create a comprehensive overview of all things acrylic, but rather to set the stage for a process and mind-set of informed experimentation.

WHAT IS ACRYLIC PAINT?

Put simply, all paint is essentially pigment mixed with a binder—a fluid that binds the pigment and dries to a form a more-or-less flexible film. The traditional binder for oil paint is linseed oil. For watercolor, it's gum arabic. For tempera, it's egg yolk. For encaustic, it's beeswax. To a very large extent, the characteristics of a binder determine the characteristics of a paint made from it. Gum arabic, for instance, remains water soluble when it dries. Therefore, so does watercolor.

The binder for acrylic paint is an emulsion made from of an acrylic polymer and water, also known as an acrylic dispersion. Because it is synthetic, its characteristics are not so limited. Although one of acrylic paint's earliest selling points was that it dries quickly, for instance, Golden now produces a product line of acrylic paints called OPEN, with extended drying times, formulated to mimic the handling properties of oil paint.

The very nature of acrylic paint permits tremendous variation. However, a few characteristics persist: In its wet state, acrylic paint is water soluble; when dry, it is water resistant. These characteristics alone make acrylic

Tip:

About student-grade acrylic paints: Student-grade paints have a considerably lower percentage of pure pigment than professional-grade paints. In practice, they can be very frustrating to work with and are generally not worth the savings. A better way to save money is to buy small quantities of professional-grade paints and then extend them as needed with mediums, which are far less expensive than paints.

paint extremely useful; no other paint offers so much potential for experimentation in the studio. Acrylic can be used for mimicking the subtle washes of watercolor or the thick impastos of oil paint. But it is not only the chameleon of all paints; it also can be used to create an endless variety of surfaces and effects that were never possible before its invention.

Acrylic paint is available in a variety of viscosities, ranging from thin and watery (airbrush paint) to thick and bulky (heavy body acrylics). It comes in a number of sheens, from glossy to satin to matte.

{ COLOR AND PIGMENTS }

There are many different ways to think about color, from its optical impact and psychological effects to its cultural and historical references. For those working with paint, however, a basic understanding of pigments is fundamental to knowing how to mix colors and how to use them with one another.

Art and craft supply stores commonly carry one or more lines of very inexpensive paints, often labeled with color names such as Apricot, Pumpkin, and Sandstone. These types of paint are generally made from mixtures of various undisclosed pigments, making it impossible to use them to really learn about color. They are intended to be used straight from the jar or tube and, because they are already mixtures, are not well suited to mixing.

Professional lines of artist paints, on the other hand, are named for their pigments, such as Burnt Umber, Cadmium Red, and Ultramarine Blue. These types of paint are frequently referred to as *pure pigment* colors; each is formulated with a single pigment as opposed to a mixture of pigments.

The best way to learn how to mix colors is to learn the particular characteristics of pure pigments, some of which have been used for millennia and some of which have only been around for a few decades. While every pigment has its own properties, it is helpful to know that most pigments fall into one of two categories: organic and inorganic.

BASICS

Inorganic Pigments, which are sometimes called, include the oldest pigments known. Naturally occurring colors, such as Raw Umber and Raw Sienna, were originally mined at their source and named for their place of origin: Umbria and Siena, Italy. Both are now synthetically manufactured along with many other mineral pigments, including Carbon Black, Red Iron Oxide, Titanium White, and Cobalt Blue. In general, inorganic pigments are more opaque than organic pigments, but they also tend to have relatively low tinting strength.

Organic Pigments are newer introductions to the world, and are the result of complex chemical processes. They include Phthalo Blue, Quinacridone Red, Hansa Yellow, and Dioxazine Purple. In general, organic pigments tend to yield brighter (higher chroma) colors than inorganic pigments. They also tend to have a higher degree of transparency and extremely high tinting strength.

{ THE COLOR WHEEL AND PAINT MIXING }

One of the most confusing things about learning how to mix paint is that the names of pigments do not correspond perfectly to the names on the color wheel. Raw Umber, for example, is dark greenish yellow. Raw Sienna is dark yellow-orange. Ultramarine Blue leans slightly toward violet, and Cadmium Yellow has just a hint of orange.

For this reason, the traditional color wheel—in which red, yellow, and blue are identified as the three primary colors—is best seen as a theoretical guide. In practice, the best way to learn how to effectively mix color is to learn about and experiment with mixing pure pigment colors.

MEDIUMS

Think of mediums as paint without pigment. Because pigment is the most expensive ingredient in paint, acrylic mediums are ounce-by-ounce significantly less expensive than acrylic paints and therefore provide an economical way to extend them. More importantly, mediums are used to modify the characteristics of paint, making it thicker, thinner, glossier, more transparent, more matte, harder, softer, etc. Although several manufacturers produce a good range of acrylic mediums, this section outlines Golden brand mediums, which cover a remarkable array of applications.

{ GELS }

Ranging from crystal clear to translucent, gels are extremely useful for altering the viscosity of acrylic colors to varying degrees, modifying sheen, and increasing transparency. Golden Soft Gels, Regular Gels, Heavy Gels, and Extra Heavy Gels are all available in gloss, satin, and matte finishes, all of which can be intermixed for extreme control over subtle shifts in their properties.

Some particularly useful Golden Gels:

Soft Gels are like yogurt in consistency. They are ideal to use as glue for collage, especially on textured materials.

Regular Gels have the same consistency as heavy bodied acrylics and are therefore perfect for extending heavy bodied paints, increasing their transparency, and modifying their sheen without altering their consistency.

Heavy and Extra Heavy Gels add thickness and body to paint, will hold peaks for impasto effects, and will generally increase the appearance of brushstrokes and marks made with palette knives.

Self Leveling Clear Gel has a resinous consistency that flattens out and dries to a clear, glossy, flexible film. When added to fluid acrylics, it eliminates brushstrokes entirely and increases transparency. Because of its leveling properties, it is also a good choice for creating acrylic skins.

{ PASTES }

Unlike gels, pastes are opaque. They can be used to modify the consistency of acrylic paint without dramatically affecting the strength of its color or increasing its transparency. When dry, most pastes are significantly harder that most gels, making them excellent for building textural or even sculptural surfaces.

Some particularly useful Golden Pastes:

Molding Paste is great for building up textures. It is far more economical for this purpose than using thickly applied, unaltered, heavy bodied paints. It is also helpful for mixing with fluid acrylics to create a heavy bodied paint that is both opaque and matte.

Hard Molding Paste dries to an extremely rigid surface that can be sanded and carved, either by hand or with power tools.

Light Molding Paste is useful when creating large textured works on canvas or other pliable supports. When wet, it weighs less than half of what regular molding paste weighs, so it will not pull or stretch the support when working vertically.

Crackle Paste has the same consistency as Light Molding Paste, but it is formulated to crack as it dries. It will develop large cracks when applied thickly and fine cracks when applied thinly. When dry, it is quite absorbent and takes washes and glazes well.

{ FLUIDS }

In general, fluid mediums increase fluidity and lower viscosity. It is important to realize that fluid mediums are not simply gels and pastes with water added. Rather, they are acrylic polymers that have been formulated to function in a fluid state. When mixed with acrylic paints, they maintain color vibrancy far better than diluting paints solely with water.

Some particularly useful Golden Fluid Mediums:

Acrylic Glazing Liquid extends the normal drying time of acrylic paints and is therefore useful for blending and creating glazes over large areas.

Polymer Medium has a thick, syrupy quality that makes acrylic paint feel more like oil. It dries to a high gloss and is good for glazing when extended drying time is not desired.

Fluid Matte Medium is a great standard medium for fluid acrylics. It lowers sheen and increases transparency. It works well as a glue for collage, especially with smooth papers. It has a toothy surface when dry, so it is also useful as a clear gesso for paper.

Matte Medium has similar uses to Fluid Matte Medium, but because it is thicker, it creates a bulkier paint mixture. It is better as a clear gesso for canvas because it fills in the texture of the fabric more readily than fluid medium does and therefore requires fewer coats.

Airbrush Medium is the thinnest of Golden's Fluid Mediums and can be used to dilute even the thickest acrylic paint to an ink-like consistency, which can be applied with brushes, mechanical pens, spray bottles, or an airbrush.

{ SPECIALTY POLYMERS }

Golden makes a number of polymers that are designed to change very specific attributes of acrylic paint mixtures. As a group, these have very low viscosity and are even thinner than Fluid Acrylics. Several of them have distinctive qualities that make them useful by themselves.

Some particularly useful Golden Specialty Polymers:

GAC 100 is ideal for sealing wood or Masonite panels prior to applying gesso. It makes the surface less absorbent and functions as a stain blocker, preventing the discoloration of light-colored areas in finished paintings, which occurs due to impurities bleeding out from panels when they become wet during the priming process. Because of its fluidity, GAC 100 is also the best polymer to use for wetting dry pigments in the making of homemade paints.

GAC 500 has self-leveling qualities that will reduce the appearance of brushstrokes in glaze mixtures. It also increases the hardness of acrylic paints and therefore is helpful with hard-edge techniques, both as a paint additive and for sealing masking tape, especially when working with glossy surfaces.

WASHES AND GLAZES

Many beginning artists assume that paint should always be used straight from the jar or tube. But this severely limits the kinds of marks and surfaces that can be made. It also makes painting much more expensive than it needs to be. Because acrylic paint is water soluble in its wet state, it is particularly easy to dilute it to make washes and glazes, which can be mixed in an infinite variety of ways to suit an enormous range of applications.

Wash is the term used for paint mixed with water. Washes are especially useful when working on absorbent surfaces, but they can also be experimented with over less absorbent, painted areas. Depending on how diluted the mixture is, a wash will often bead up when it is applied to a nonabsorbent surface. This effect can be very interesting. But it is important to realize that highly diluting acrylic paint with water causes the binder to break down. Conventionally, it is ill advised. However, experimental surfaces achieved with highly diluted paint often adhere surprisingly well. For added stability, surfaces can be sealed with subsequent layers of glaze to help improve overall adhesion to the support.

Glaze is the term used for paint mixed with a transparent medium. Glazes are traditionally used to build up transparent layers of color. Because of the exceptionally wide range of acrylic mediums now available, the value of using glazes is not limited to issues of transparency. Glazes can be used to alter the sheen of a painting, or a portion of a painting, as well as the viscosity or working consistency of paint. Golden Self Leveling Clear Gel, for example, can be used to mix a glaze that flattens out as it dries, eliminating brushstrokes. Glazes have a higher viscosity than washes, and when used with experimental techniques, ensure a durable, flexible paint film.

 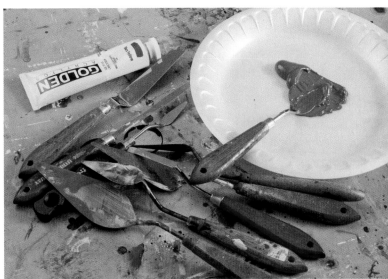

TOOLS

{ BRUSHES }

Artist's brushes can be surprisingly expensive, especially those made from natural hair. Fortunately, experimenting with acrylic paint doesn't often require the kind of costly brushes needed for fine detailed work. In fact, for most experimental acrylic techniques, it makes more sense to use inexpensive "chip" brushes, available at home centers and craft stores.

A good rule is, use higher-end brushes only when the brushstrokes show. For washes on an absorbent ground, for example, a good-quality natural-hair watercolor brush is very helpful because the stiff bristles of an inexpensive brush will leave marks in the surface. For flat areas of fluid acrylic, a higher-quality synthetic brush (the kind made for acrylic painting) is best. Watercolor brushes are too soft for pushing acrylic paint around and stiff bristle brushes leave pronounced lines in the surface. Beyond that, the best way to learn what kinds of marks different brushes make is to experiment. But don't be fooled into thinking that a huge collection of expensive brushes is essential. Cheaper brushes allow for greater risk taking and freer experimentation.

{ PALETTE KNIVES }

Palette knives are endlessly useful in the studio. While very small quantities of paint may be mixed with brushes, palette knives do a better job of smoothly blending colors and keeping unwanted air bubbles out, especially with heavy bodied acrylic paints. But mixing paint is only one of their functions. They are also great for creating a wide range of textures in wet or semidry paint. They come in dozens of shapes and sizes, so it is a good idea to gradually accumulate an assortment of them.

BASICS

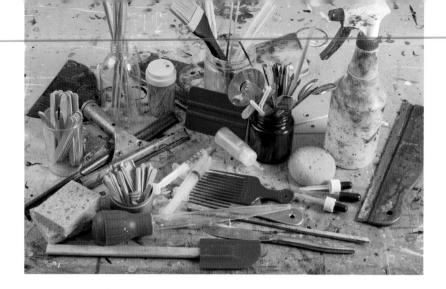

NONTRADITIONAL TOOLS

When looking for tools to use in experimenting with acrylic paint, art supply stores are not the only place to look. Hardware stores, home centers, and dollar stores are loaded with useful items. Here's a short list of some commonly available items to look for:

* spatulas
* basters
* plastic silverware
* toothpicks
* toothbrushes
* drinking straws
* wooden skewers
* Popsicle sticks (a.k.a. craft sticks)
* squeegees
* spray bottles
* sponges (all types)
* combs
* eyedroppers
* foam rollers (the kind used for house painting)
* syringes

SUPPORTS

Also known as substrates, supports, in the most basic sense, are the things that you paint on. For more than one thousand years, the standard support for portable paintings (those that were not done directly on walls) was either wood panel or vellum. Canvas became a popular support during the sixteenth century, and it remains what most people think of as the norm for painting. But panels and paper (the modern equivalent of vellum) are both well suited for experimenting with acrylic paint. Panels offer a rigid surface that will not dent and pull the way stretched canvas does, allowing for a wide range of treatments. Paper, which is generally stretched on a rigid panel so it doesn't buckle, is similarly durable and can be used with acrylic to mimic the effects of watercolor just as easily as it can be gessoed and treated like any other flat painting surface.

STRETCHING PAPER

A common practice for watercolorists, stretching paper is a basic method used to keep it from buckling as it dries. Traditionally, brown tape is used to adhere the paper in its wet state to a rigid wooden board. An easier and tidier method is to use standard staples and Homasote board, a heavy cardboard of sorts that can be reused again and again for many years.

The advantage of using staples instead of tape is that once the work is complete, the staples can be easily removed, leaving the Homasote board clean and ready to reuse. Brown adhesive tape, on the other hand, must be scraped off, which is messy and time consuming.

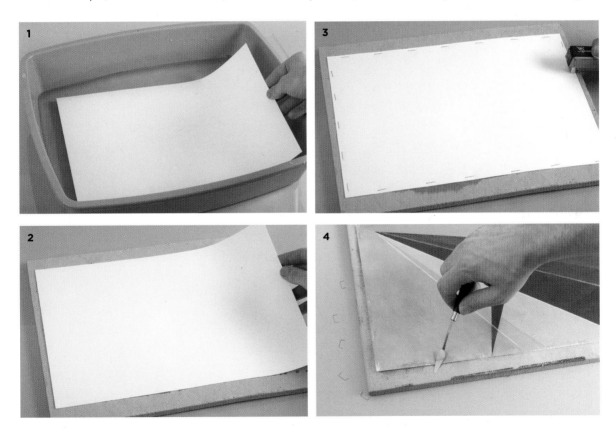

STEP 1: Soak the paper in a tray of clean water for a minimum of 3 minutes, or until the paper is evenly pliable. The amount of time needed for this is dependent on the weight of the paper and how heavily sized it is.

STEP 2: Place the paper on a clean board and let it sit until no visible sheen remains and the corners are just beginning to curl up. It is important to wait until this happens because up

until this point, the paper is still absorbing water and therefore is still expanding. The idea here is to staple the paper down when it is at its most expanded state. Then, it will shrink as it dries, leaving a taut surface.

STEP 3: Using a standard stapler, staple the paper to the board. Staples should be positioned at least ¼" (6 mm) in from the edges of the paper and no more than 2" (5.1 cm) apart.

STEP 4: Once the painting is complete, remove the staples with a small palette knife.

About Paper Sizing

Sizing solutions, made from natural or synthetic forms of starch or gelatin, are used during the manufacturing of paper to control its absorbency. Without sizing, paper fibers quickly absorb ink and paint through capillary action. Sizing prevents color from bleeding through paper, and prevents hard edges from becoming fuzzy. When size is added to paper pulp before sheets are formed, the paper is referred to as being *internally sized*; and when it is added after sheets are formed, it is referred to as being *surface sized*. Some papers are sized both ways.

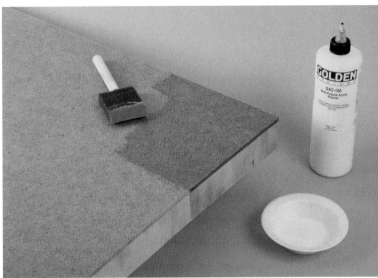

{ WOOD PANELS }

Wood panels are often made from plywood or Masonite and mounted to a framework (or "cradle") made from pine, poplar, or birch. Although many different kinds of wood and wood products can be used, what is most important is that the surface to be painted is free from oils and waxes. When in doubt, wipe the surface down with denatured alcohol.

Cradling is the term used for the support structure on the back of a wood panel, which provides rigidity and stability.

Always prime a wood or Masonite panel before applying gesso. Here, GAC 100 is used.

{ PREMADE ALTERNATIVES }

Stretched canvases and premade panels are widely available and in an increasingly broad range of sizes. Ampersand makes a variety of boards with different surfaces, including Aquabord, which is coated with a highly absorbent ground that is well suited to watercolor techniques.

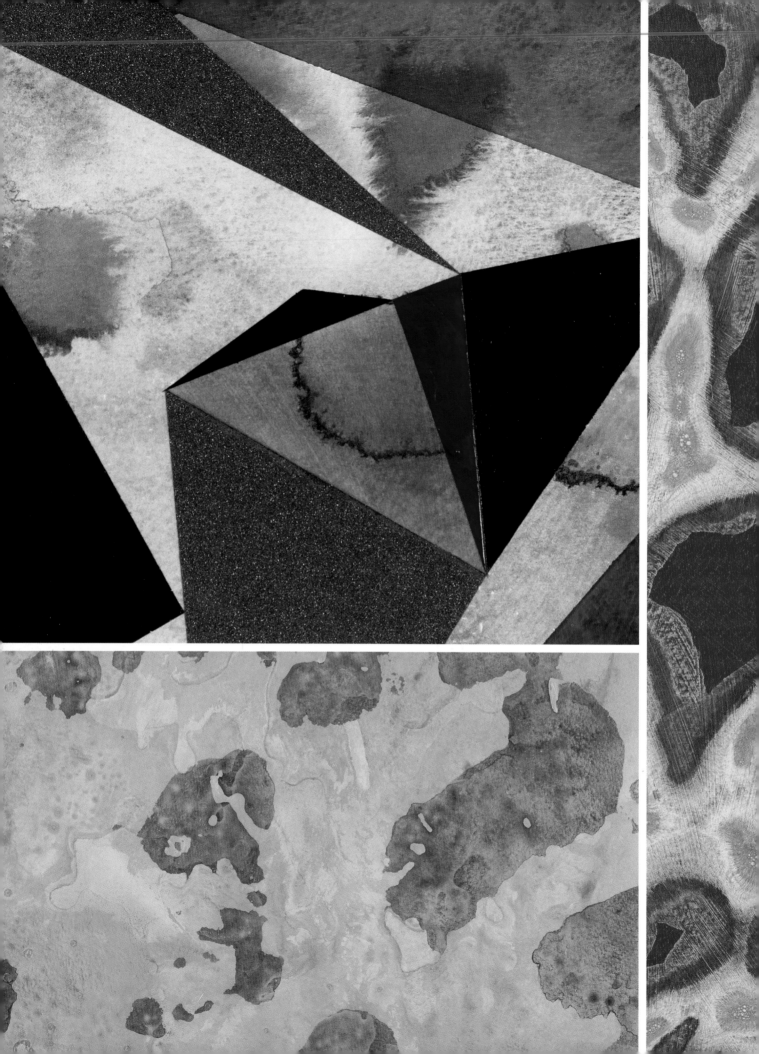

TECHNIQUES FOR EXPERIMENTING WITH ACRYLIC PAINT

Acrylic paint can be used in an endless variety of ways. Unlike oil, which must be applied "fat-on-lean," acrylic paint can be mixed with various acrylic mediums to a wide variety of consistencies, which can be applied in any order. It can have the runniness of ink or can be as thick as clay. It can be glossy or matte, opaque or translucent, smooth or textured, and it can have any degree and virtually any combination of these characteristics.

Specialty mediums further expand acrylic paint's possibilities and usefulness. They can make paint film hard enough to be sanded and carved, or soft enough to feel like rubber. There are mediums specially formulated to create dramatic crackle patterns and others designed to ensure a smooth film that flattens out and dries like a sheet of plastic. There are acrylic mediums that make overly absorbent surfaces less absorbent, and nonabsorbent materials absorbent.

Because acrylic paint dries quickly and is mixable with water, it lends itself to experimentation with common tools and materials. Through trial and error, the techniques outlined here have proven to be effective and useful. They are intended to provide a foundational knowledge of what acrylic paint can do and to inspire experimentation with the vast array of acrylic materials now available.

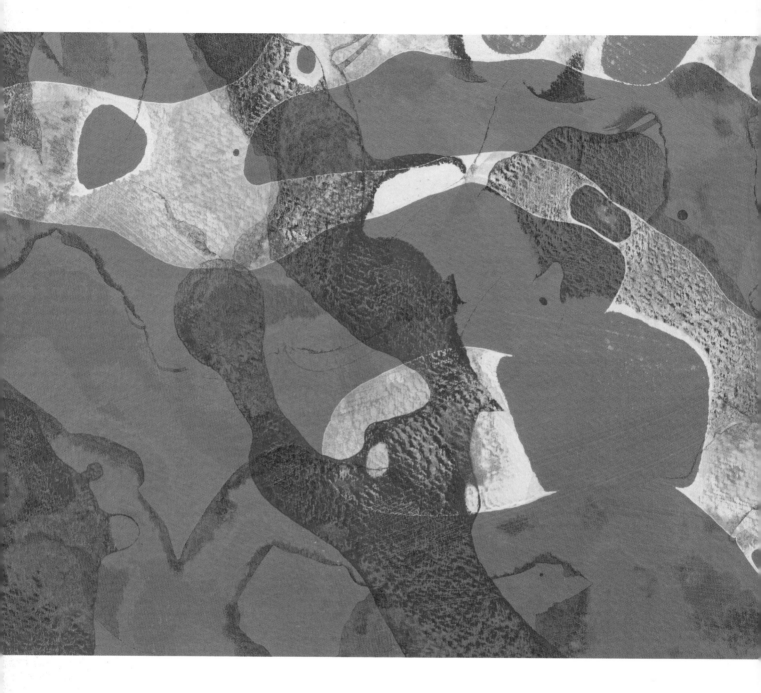

PALIMPSEST

CREATING A RICHLY LAYERED SURFACE BY MAKING SHAPES AND THEN WIPING THEM PARTLY AWAY

The word *palimpsest* generally refers to historical surfaces that were scraped or erased and then written upon again, with some traces of the older marks remaining. Similarly, this technique involves building surfaces by pouring paint onto a support, allowing the paint to partially dry, wiping off the remaining wet portion, and then repeating the process to accumulate overlapping layers of partially erased shapes.

{ **MATERIALS** }

> FLUID ACRYLICS
> DISTILLED WATER
> TERRY-CLOTH RAGS

Getting Started: Begin with a support that has been coated with gesso or acrylic color. A smooth surface, such as stretched paper or a wood panel, will work better than canvas.

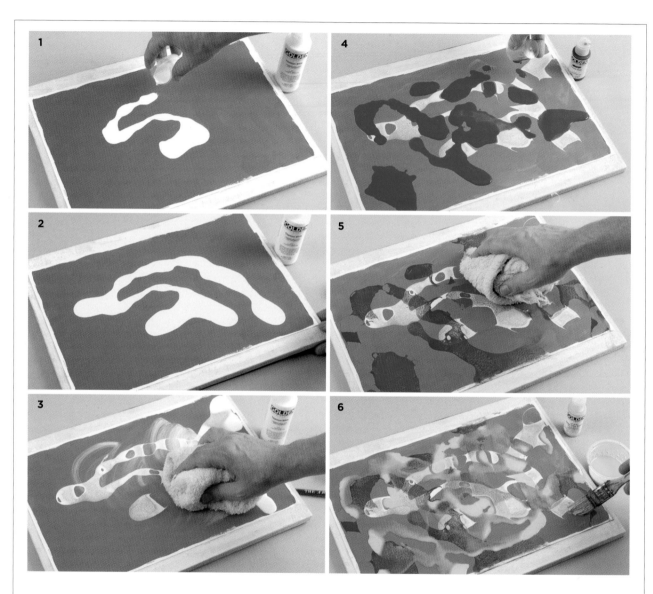

STEP 1: Dilute a small quantity of fluid acrylic with distilled water (approximately 1:4) and mix well. Pour the mixture onto the support to form a puddle.

STEP 2: Tilt the support and move the puddle around to form a shape.

STEP 3: Watch the paint closely until it is partially dry and some wet areas remain. Using a damp terry-cloth rag, wipe the remaining wet paint off the surface entirely, leaving only the dried areas, which will have formed a series of interesting biomorphic shapes.

STEP 4: Repeat the process of forming puddles of diluted paint with another color mixture. Try making these puddles different in size.

STEP 5: Allow the puddles to dry only partially, and then wipe off the remaining wet paint.

STEP 6: Instead of pouring, try making puddles using a brush. This allows greater control to form linear shapes.

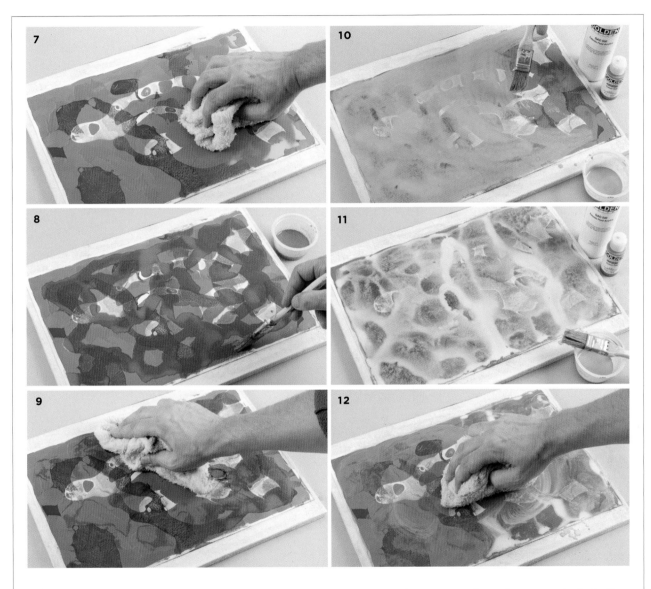

STEP 7: Again, allow the puddles to partially dry, and then wipe off the remaining wet paint.

STEP 8: Apply another color mixture. Transparent colors will add greater complexity to the composition without totally obscuring previous layers.

STEP 9: Allow the color to partially dry and then wipe off the remaining wet paint.

STEP 10: Make a new color mixture and dilute it 1:1 with fluid acrylic medium. Using a color that is analogous to the background color will create subtle tonal shifts. Cover the entire surface this time.

STEP 11: Watch the surface carefully. Notice how the paint forms puddles on its own in some areas and starts to dry where it is thinner.

STEP 12: When this layer is partially dry, wipe the entire surface.

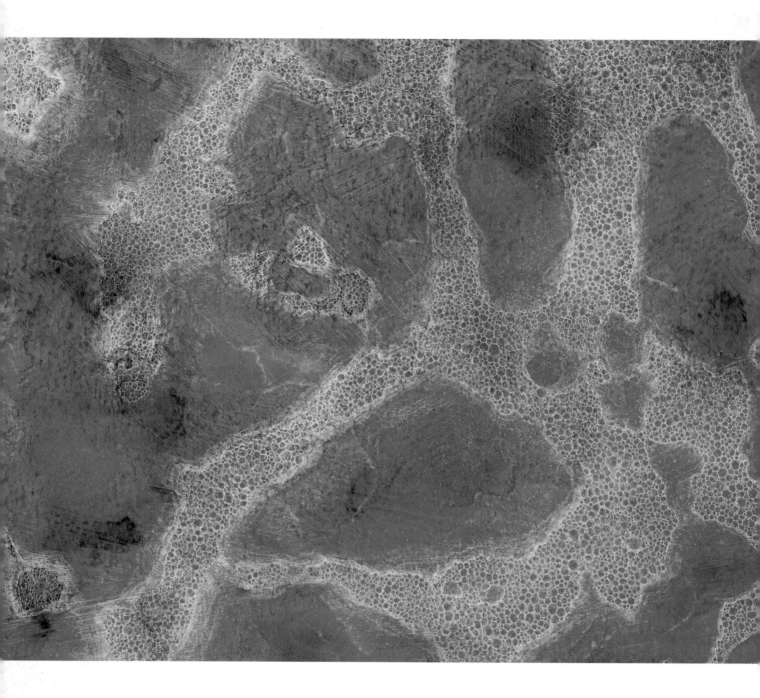

TINY BUBBLES

USING LIQUID SOAP TO CREATE A FROTHY TEXTURE

For this technique, fluid acrylic colors are mixed with a small amount of liquid soap to create a sudsy mixture that dries to form an interestingly textured surface.

{ MATERIALS }
> FLUID ACRYLICS
> DISTILLED WATER
> LIQUID DISH SOAP (CLEAR, ADDITIVE-FREE TYPE IS BEST)
> FLUID MEDIUM SUCH AS GAC-100

Getting Started: Begin with a smooth surface that has been coated with either gesso or acrylic color.

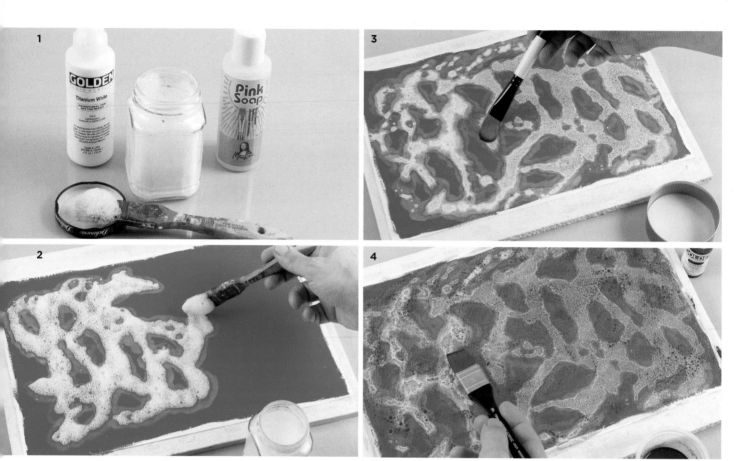

STEP 1: In a jar with a tight-fitting lid, mix a fluid acrylic with distilled water at a ratio of 1:3, and then add a small amount of liquid soap (about ⅓ as much soap as paint). Cover the jar and shake it vigorously until it becomes foamy.

STEP 2: Using an inexpensive brush, scoop the foamy paint out of the jar and apply it to the support.

STEP 3: Once the surface is completely dry (several hours) apply a coat of fluid medium to the entire area to seal it.

STEP 4: Mix a color wash using another acrylic color and water (1:4). Apply to the surface with a soft brush. Let the wash dry. If further layers are desired, seal the surface again with an isolation coat before proceeding.

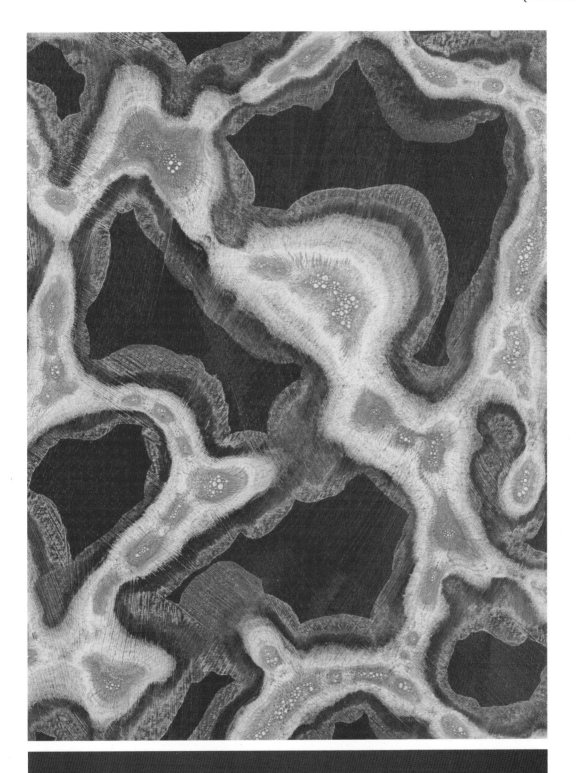

Variation:

Experiment with different proportions of fluid acrylic, water, and liquid soap. Here, a tiny drop of soap and a larger quantity of water was added to a mixture of Phthalo Green and Titanium White. The resulting foamy paint was applied with a brush to a background of Red Oxide.

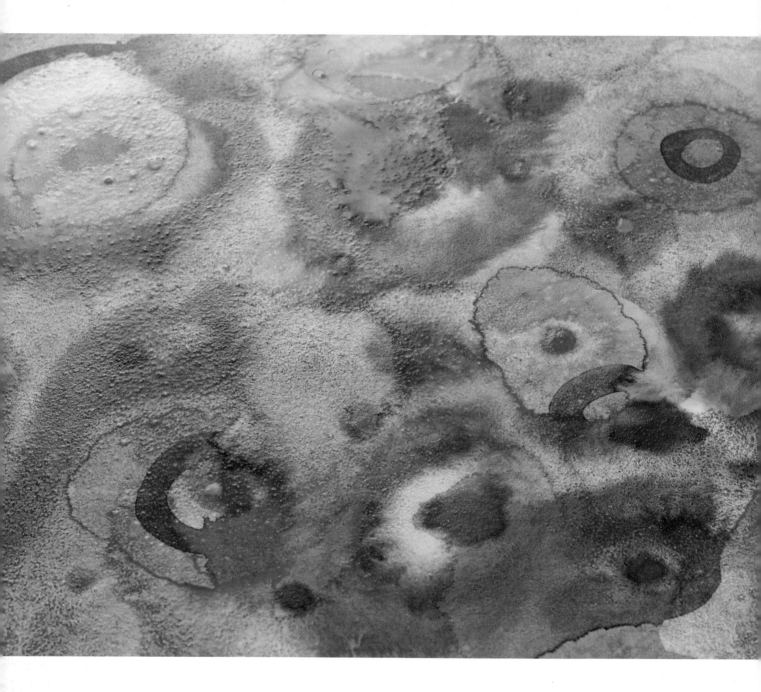

ACRYLIC AS WATERCOLOR

USING ACRYLIC ON ABSORBENT SURFACES TO MIMIC WATERCOLOR EFFECTS

One of the biggest challenges of using watercolor is that it remains water soluble when it dries. Working in layers is nearly impossible as each new layer at least partially dissolves whatever is below. Unlike watercolor, acrylic paint is water resistant when dry, allowing endless layers to be built up without destroying the layers below.

{ MATERIALS }
> ABSORBENT SUPPORT, SUCH AS STRETCHED WATERCOLOR PAPER, AQUA-BORD, CANVAS, OR PANEL COATED WITH GOLDEN ABSORBENT GROUND
> FLUID ACRYLICS
> DISTILLED WATER

Getting Started: Prepare an absorbent support.

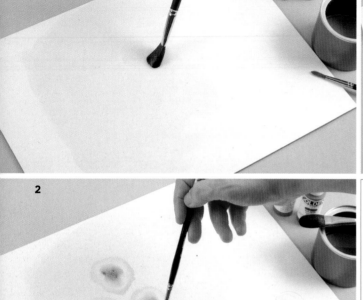

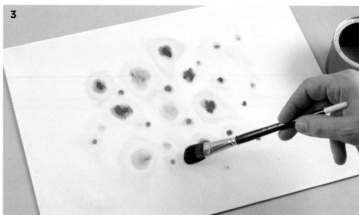

STEP 1: Using a soft brush, dampen a portion of the absorbent ground with distilled water.

STEP 2: Begin to create marks using pure fluid acrylics, allowing each mark to bleed across the dampened surface.

STEP 3: Allow the first series of marks to dry fully. Then, to start a new layer, dampen the surface again with a soft brush and water.

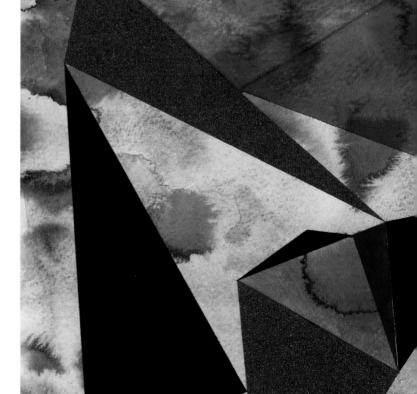

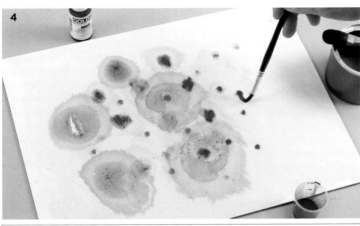

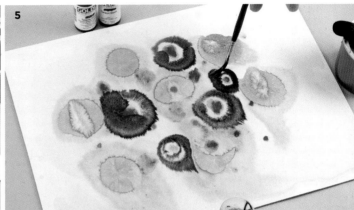

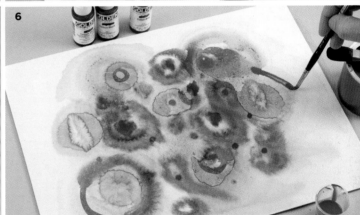

STEP 4: Apply a new series of shapes. Try using a slightly diluted mixture of fluid acrylic and water (1:1), which will allow more freedom with the brush and will create more subdued washes of color.

STEP 5: Continue adding shapes with additional colors and then allow this layer to dry.

STEP 6: Rewet the surface and continue adding washes of color. Notice that the earlier layers remain intact.

Combined Techniques:

Crisp, hard-edge shapes can be made on absorbent grounds using the taping technique outlined on pages 40–41. Just make sure the surface is fully dry before applying tape. In this detail, a mottled ground was formed wet-into-wet. Once dry, hard-edge shapes were created using Micaceous Iron Oxide, Carbon Black, and Quinacridone Burnt Orange, as well as a glaze made from Phthalo Blue and Fluid Matte Medium.

TECHNIQUES FOR EXPERIMENTING WITH ACRYLIC PAINT

HARD EDGE

USING SEALED MASKING TAPE TO GET CRISP, CLEAN EDGES

Many artists use masking tape to make sharp lines, but even the best painter's tapes can leak, especially when using fluid acrylic or glazes. This technique ensures that the edges of the tape are sealed tight. It even works with watery washes that normally are guaranteed to creep under unsealed painter's tape.

{ MATERIALS }

> PAINTER'S TAPE
> FLUID MATTE MEDIUM OR GAC 500
> FLUID ACRYLICS

Getting Started: Choose a brand of painter's tape, such as Scotch Blue or Frog Tape.

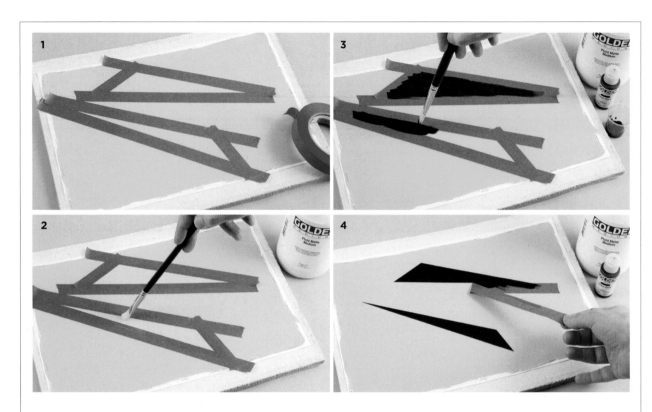

STEP 1: Use painter's tape to tape off some shapes on a support that has been coated with either gesso or paint.

STEP 2: Seal the edges of the tape by coating them with Fluid Matte Medium or GAC 500. Allow the medium to dry and apply a second coat.

STEP 3: Once the sealed edges of the tape are dry, fill in the shapes with fluid acrylic color. Allow the paint to dry, and apply a second coat if needed.

STEP 4: Carefully pull away the tape and allow the paint to fully dry.

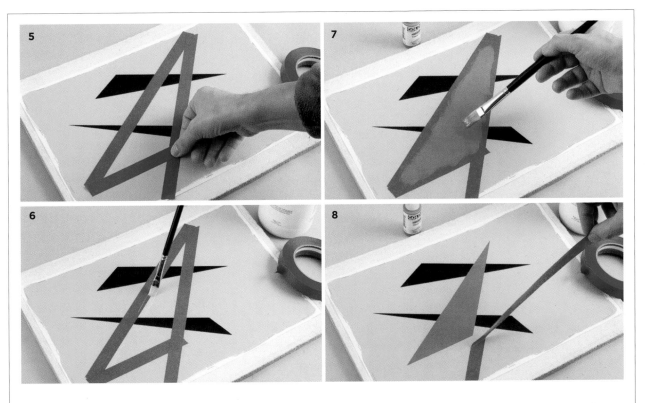

STEP 5: Tape off a new shape that overlaps the earlier ones.

STEP 6: Seal the tape edges (repeat step 2).

STEP 7: Fill in the new shape with a contrasting color.

STEP 8: Carefully remove the tape and allow the paint to dry.

Product Tip:

Several different acrylic mediums work well for sealing painter's tape. In general, harder mediums create a cleaner break when peeling off tape. Softer mediums or gels can be too pliable and can tear into the paint film when the tape is being removed. When working with a matte surface, Golden Fluid Matte Medium works very well. For glossy surfaces, Golden GAC 500 is ideal because it produces a hard, thin, glossy film. It also levels out nicely, so it won't show brushstrokes as much as thicker mediums.

TECHNIQUES FOR EXPERIMENTING WITH ACRYLIC PAINT

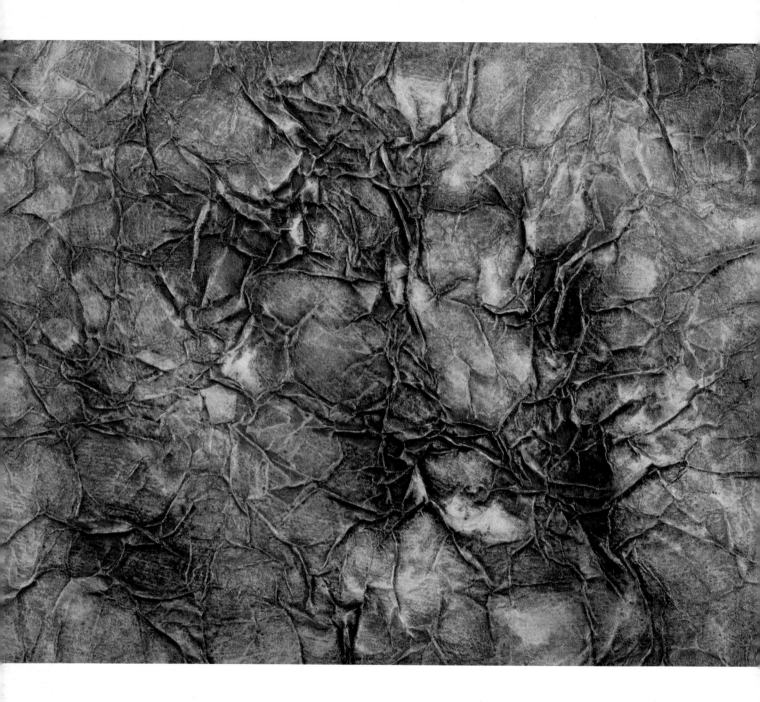

WRINKLED RICE PAPER

CREATING TEXTURE USING AN AGE-OLD MATERIAL

Rice paper (which is not actually made from rice) is a general term for a number of traditional Japanese papers that are also known as *Kozo*. Because it tends to be both strong and translucent, it lends itself well to layered collage applications.

For this process, crumpled rice paper is pasted to a brightly painted surface, producing both a physical texture and a mottled colored surface. The paper adheres snuggly to the painted surface in some areas and forms shallow air pockets in others. The resulting texture responds well to subsequent washes or glazes.

{ MATERIALS }

> FLUID ACRYLICS
> RICE PAPER, SUCH AS HOSHO, OKAWARA, OR MULBERRY
> FLUID MATTE MEDIUM

Getting Started: Begin with a smooth surface coated with a rich, saturated acrylic color.

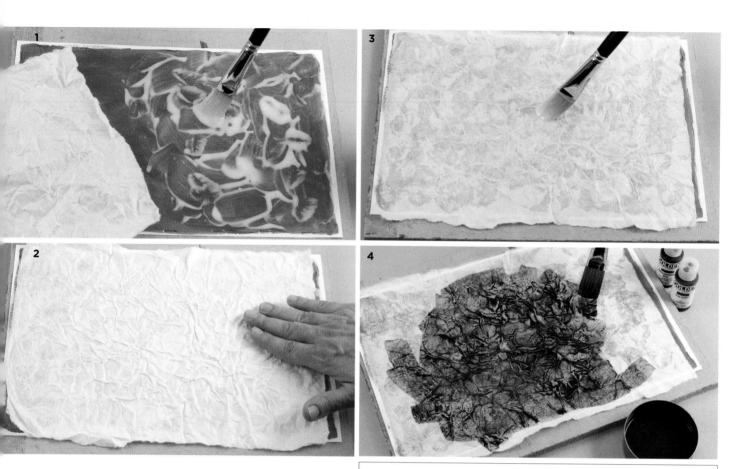

STEP 1: Crumple up a sheet of rice paper, unfold it, and keep in nearby. Apply a generous amount of Fluid Matte Medium to the entire surface of the support.

STEP 2: Lay the crumpled rice paper over the medium immediately, while it is still wet. Smooth out the paper without pressing too hard. Leave plenty of wrinkles.

STEP 3: Immediately apply a generous amount of Fluid Matte Medium on top of the rice paper, further saturating it and flattening it out. Some air pockets will remain.

STEP 4: Once the surface is fully dry, apply a contrasting color wash made from a mixture of fluid acrylic and water (1:3).

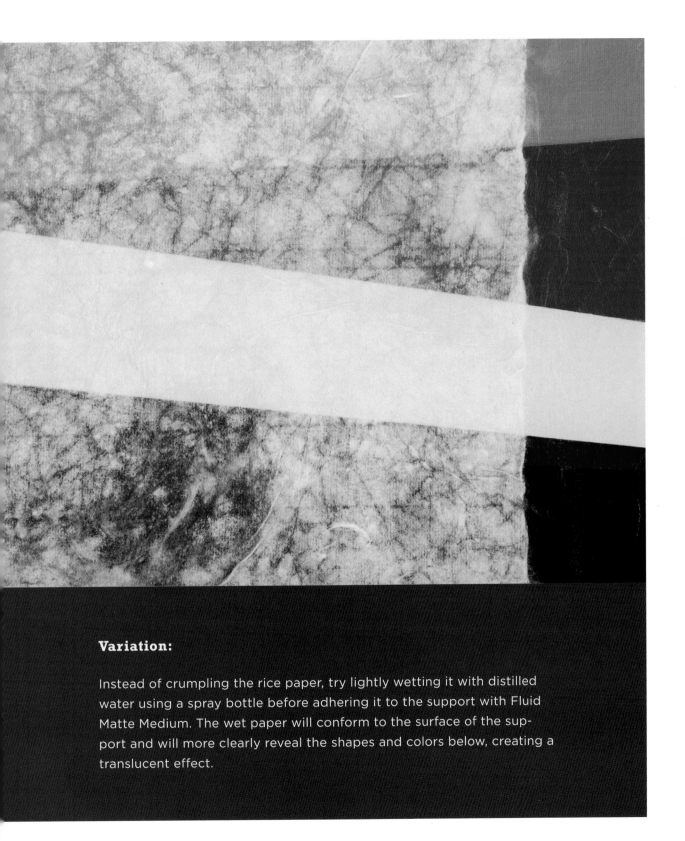

Variation:

Instead of crumpling the rice paper, try lightly wetting it with distilled water using a spray bottle before adhering it to the support with Fluid Matte Medium. The wet paper will conform to the surface of the support and will more clearly reveal the shapes and colors below, creating a translucent effect.

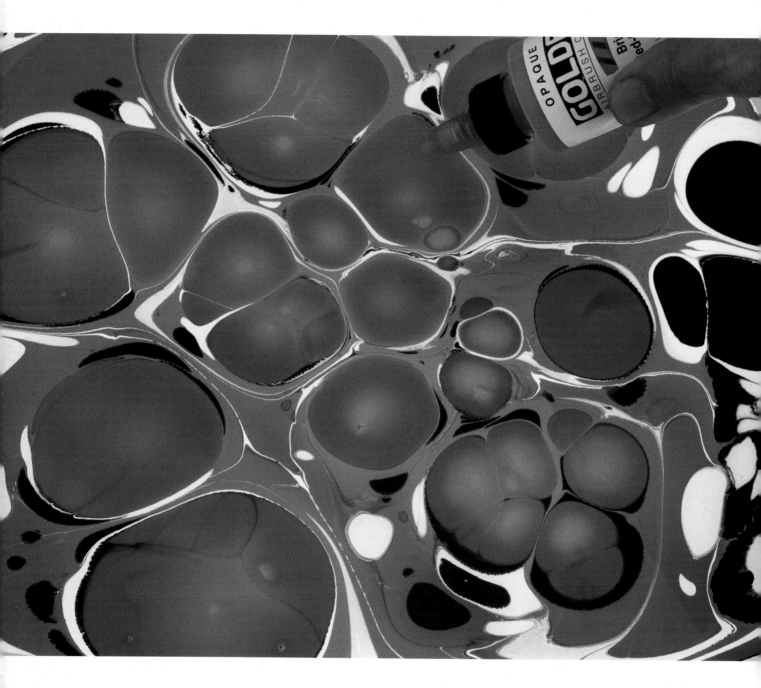

MARBLING

CREATING A MODERN ADAPTATION OF AN ANCIENT PROCESS

The process of marbling paper is thought to have originated in East Asia as early as the tenth century. Similar practices were developed in the Middle East, eventually spreading to Europe during the seventeenth century. Although a variety of methods have evolved through the ages, the core principle of each involves floating pigment on the surface of a size, a viscous liquid traditionally made from carrageenan—the extract of a variety of seaweed known as Irish moss. The pigment is then transferred to paper that has been treated with a mordant (alum), which bonds it to the paper.

Although this simplified technique can be used to make more-or-less traditional marbled papers, it is conceived for the purpose of creating interesting abstract images on paper, which can be further manipulated using other techniques in this book. The sheets can be mounted to canvas or panels, or used for collage work.

{ MATERIALS }

> PAPER – EXPERIMENT WITH DIFFERENT TYPES, INCLUDING: MASA JAPANESE PAPER (A VERY LIGHTWEIGHT PAPER, BEST FOR COLLAGE), LENOX (AN ECONOMICAL 100% COTTON PRINTMAKING PAPER), AND HAHNEMÜHLE INGRES (A GERMAN DRAWING PAPER, AVAILABLE IN MANY COLORS)
> ALUM (ALUMINUM SULPHATE) MORDANT (COMMONLY USED FOR FABRIC DYEING)
> METHYLCELLULOSE SIZE (COMMONLY USED AS A BOOKBINDING GLUE)
> GOLDEN AIRBRUSH COLORS OR FLUID ACRYLICS DILUTED 1:1 WITH DISTILLED WATER

Getting Started: Obtain a tray or tub large enough to accommodate your paper size. Options include: photographic developing trays, dishwashing tubs, shallow baking pans, or litter boxes.

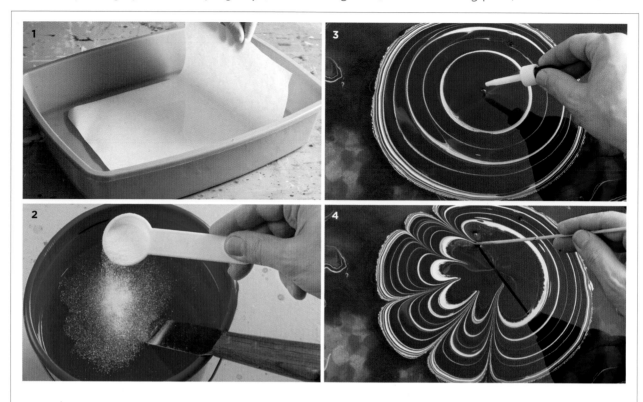

STEP 1: Mix the alum solution by adding 1 tablespoon (14 g) of alum powder to 1 cup (235 ml) of warm water, or 1 cup (224 g) to 1 gallon (3.8 L) of water. (Note: Wear gloves when handling alum, as it is caustic.) The solution can be applied to the paper with a sponge, a spray bottle, or by pouring it into a tray and then dipping the paper. Sheets of paper should then be hung up to dry. Unused alum solution may be stored in an airtight contain for 2 to 3 months. Do not treat more paper than will be used in a few days. If you treat more sheets than needed, rinse them in running water and allow them to dry fully before storing.

STEP 2: Mix the methylcellulose size as directed by the manufacturer. A standard recipe is 1 tablespoon (14 g) of methylcellulose powder per 1 quart (950 ml) of warm water, or 4 tablespoons (56 g) per gallon (3.8 L). Stir until the powder is dissolved, and allow mixture to sit until it is clear. Mix enough of the size to fill your tray or tub to a depth of about 2" (5.1 cm). The size may be used immediately, but letting it stand for several hours will ensure that the particles have fully dissolved.

STEP 3: Begin to apply paint to the size in single drops. Golden Airbrush Colors can be used straight from the bottle. If using fluid acrylics, dilute them 1:1 with distilled water and use eyedroppers. Some colors will spread across the size faster than others. If a drop of paint sinks to the bottom of the tray without spreading across the surface of the size, try diluting it with Golden Airbrush Medium, Transparent Extender, or water. Try applying drops of alternating colors in a bull's-eye pattern. Notice that with each drop, the pattern spreads farther out toward the edges of the tray.

STEP 4: At this point, the floating paint can be modified in many ways before it is transferred to paper. Traditionally, metal combs are raked across the surface to create intricate patterns. Try using toothpicks or wooden skewers to alter the pattern, or use a drinking straw to gently blow on the surface and shift the shapes around.

STEP 5: Once an interesting pattern has been achieved, carefully lay a sheet of paper on the surface of the size, initially holding it diagonally by two corners and then releasing it. This step takes some practice to ensure that air bubbles are not trapped beneath the paper.

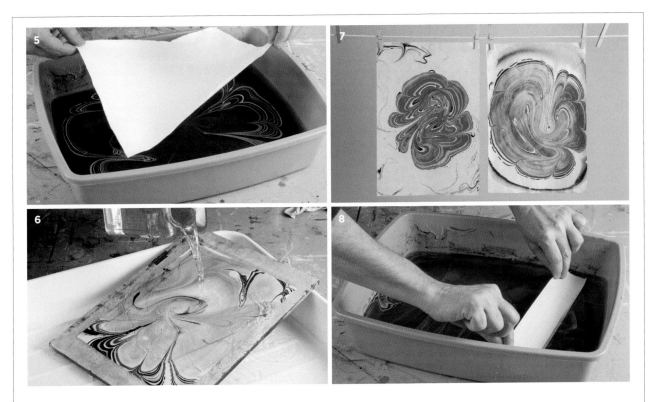

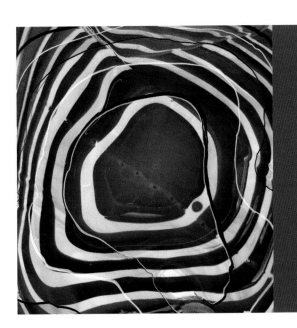

STEP 6: After a few seconds, lift the paper by grabbing the corners of one side. Remove it from the size and flip it upright on a board. Rinse the paper gently under running water to wash off excess size.

STEP 7: Hang the sheet to dry using a clothesline and clothespins.

STEP 8: To continue making images, use strips of newsprint or newspaper to soak up any remaining paint from the surface of the size, and begin a new painting. The size may be used over and over again this way. It can be covered with plastic and will keep in the tray for a week or more.

Variation:

Once a marbled sheet is dry, it can be used again, repeating the process to add more layers and to modify the image. Try using both opaque and transparent colors. In this example, alternating droplets of Opaque Carbon Black and Opaque Titanium White airbrush colors were used for the first layer. The second layer was made using the same black and white as well as Transparent Yellow Oxide and Transparent Shading Gray.

TECHNIQUES FOR EXPERIMENTING WITH ACRYLIC PAINT

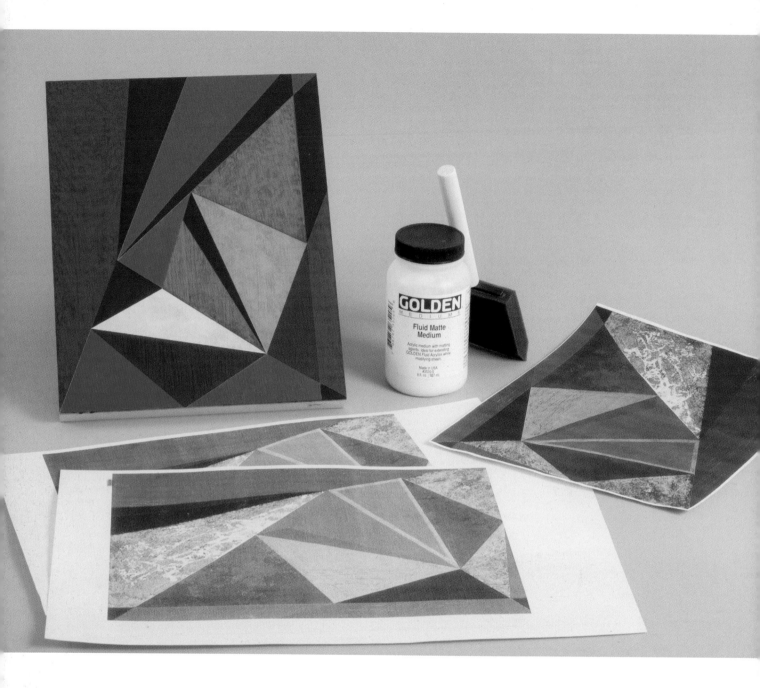

CARBON TRANSFER

USING ACRYLIC MEDIUM TO PRINT BLACK-AND-WHITE IMAGES ONTO CANVAS OR PANEL

Several processes exist for transferring images made on a laser printer or copy machine, but they often involve solvents that are toxic and unpleasant to use. This technique, which uses acrylic medium as a transfer agent, is nontoxic and simple. It is a great way to get black-and-white images onto traditional painting supports for mixed-media applications. It is also effective for creating variations on your existing artwork by photographing it, making copies of the photographs, transferring the copies onto canvas or panels, and then painting over the transferred images.

{ MATERIALS }

> TONER-BASED IMAGES PRINTED ON A LASER PRINTER OR COPY MACHINE
> FLUID MATTE MEDIUM
> CANVAS OR PANEL

Getting Started: Select images and make copies. Be sure to make the size of your copies correspond with your chosen supports.

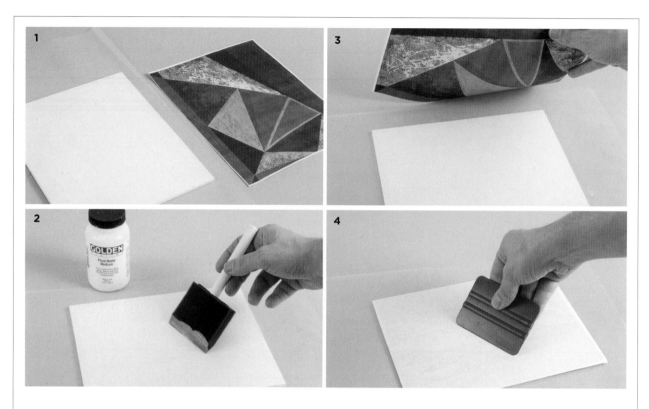

STEP 1: For this example, a photograph of a painting was copied on a copy machine. Place the copy near the support, which, in this case, is a gessoed Masonite panel.

STEP 2: Apply an even coat of Fluid Matte Medium to the panel, making sure to cover the entire surface.

STEP 3: While the medium is wet, adhere the copy facedown on the panel. To ensure an even transfer, it is imperative that this is done immediately after the medium is applied.

STEP 4: Starting at the center and working outward toward the edges of the panel, burnish the backside of the copy paper using a plastic burnish tool or a small piece of stiff cardboard.

Be sure to push out any air bubbles that may have formed.

STEP 5: Wait about 30 minutes and then peel back one corner of the copy paper slightly to see if the image has transferred. If not, try burnishing more. Once it appears that the transfer has been successful, begin to peel back as much paper as you can.

STEP 6: To remove the remaining paper, rub the surface with the tips of your fingers. The paper should come off fairly easily, leaving the carbon toner embedded in the matte medium on the surface of the panel. If needed, use a spray bottle to wet the paper slightly and help loosen it.

ACRYLIC FUSION

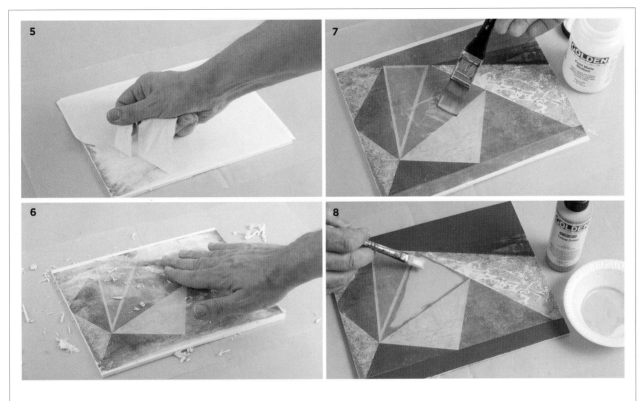

STEP 7: Allow the transfer to dry fully and then apply a new layer of fluid medium to seal the image.

STEP 8: The image may now be treated with transparent glazes or used as a ground sketch for a new painting.

Tip:

Keep in mind that the transfer process reverses images. This may be helpful with creating variations of your existing artwork. But if your image includes text, be sure to reverse it using a computer program such as Photoshop before making copies.

TECHNIQUES FOR EXPERIMENTING WITH ACRYLIC PAINT

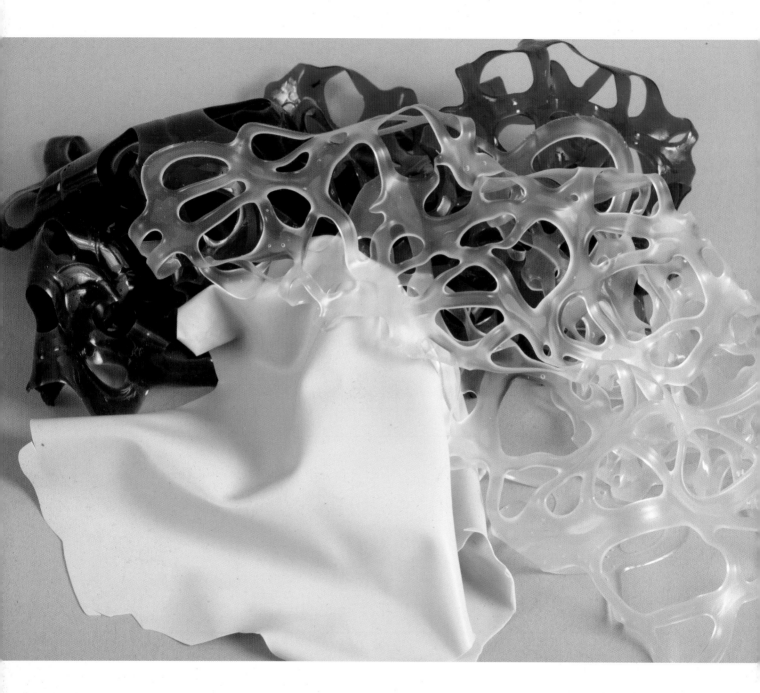

SKINS

MAKING REUSABLE ACRYLIC SHEETS

Because acrylic paint and mediums only adhere to porous surfaces, and because they dry to form a flexible film, when they are applied to nonporous surfaces they can be peeled off and remain intact. The resulting acrylic skins can be used in endless ways. They can be cut with scissors and used as collage material. They can be rolled or shaped to make sculptural forms, or they can be applied like decals to traditional supports using fluid medium or soft gel as an adhesive.

This example uses a fluid medium to create an open, mesh-like pattern. Heavy bodied mediums can be used to make acrylic skins as well, but they tend to work best for creating solid shapes, formed with a palette knife. The only mediums that do not work well for making skins are those that dry to a hard film. Also, the addition of water to any medium is not recommended for making acrylic skins, as it tends to make the film brittle.

{ MATERIALS }
> NONPOROUS MATERIAL, SUCH AS FREEZER PAPER OR PLASTIC SHEETING
> FLUID ACRYLIC MEDIUM (TRY VARIOUS TYPES FOR DIFFERENT EFFECTS)
> FLUID ACRYLIC
> SQUEEZE BOTTLE

Getting Started: Choose a medium and decide on a pattern. In this example, tinted acrylic medium is applied in a circular pattern on freezer paper to produce a mesh-like skin. Different fluid mediums will produce different results. GAC 500, used here, is very fluid and levels out to produce a delicate, paper-thin skin.

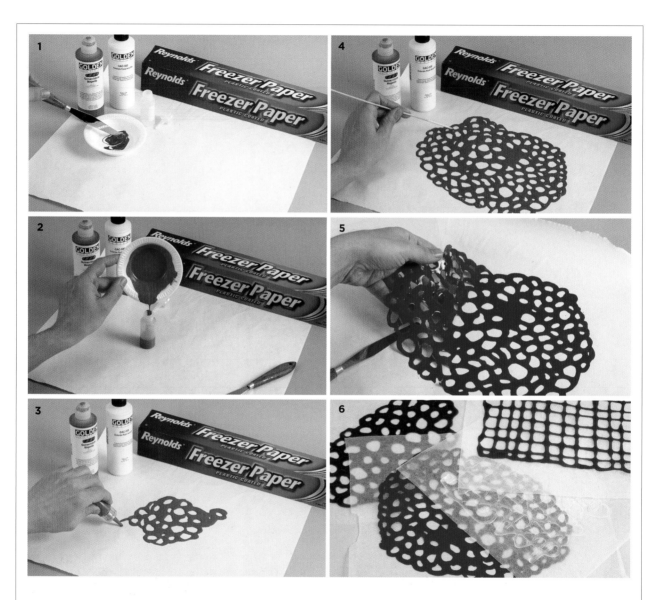

STEP 1: Lay out a sheet of freezer paper with the plastic coated side faceup. Prepare the medium, tinting it with fluid acrylic color.

STEP 2: Fill the squeeze bottle.

STEP 3: Use the squeeze bottle to "draw" an open pattern on the freezer paper.

STEP 4: Use a toothpick or skewer to pop any bubbles that have formed, and then allow the skin to dry overnight.

STEP 5: Once it is fully dry, the acrylic skin should peel off the freezer paper fairly easily. Use a palette knife to get started and assist with fragile areas.

STEP 6: Acrylic skins will remain pliable indefinitely and can be stored for future use by stacking them between sheets of wax paper, without which they will stick together.

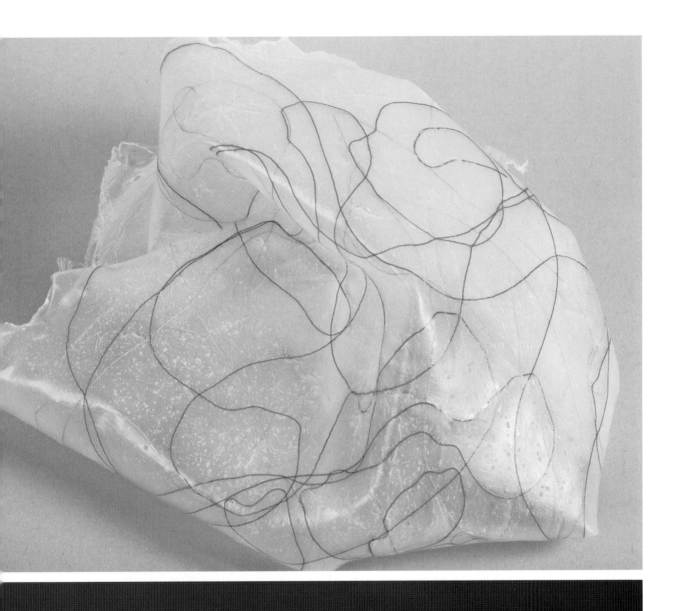

Variation:

Almost any pliable material can be added to the acrylic medium when making skins. Here, colored thread was laid into Soft Gel Matte while it was still wet.

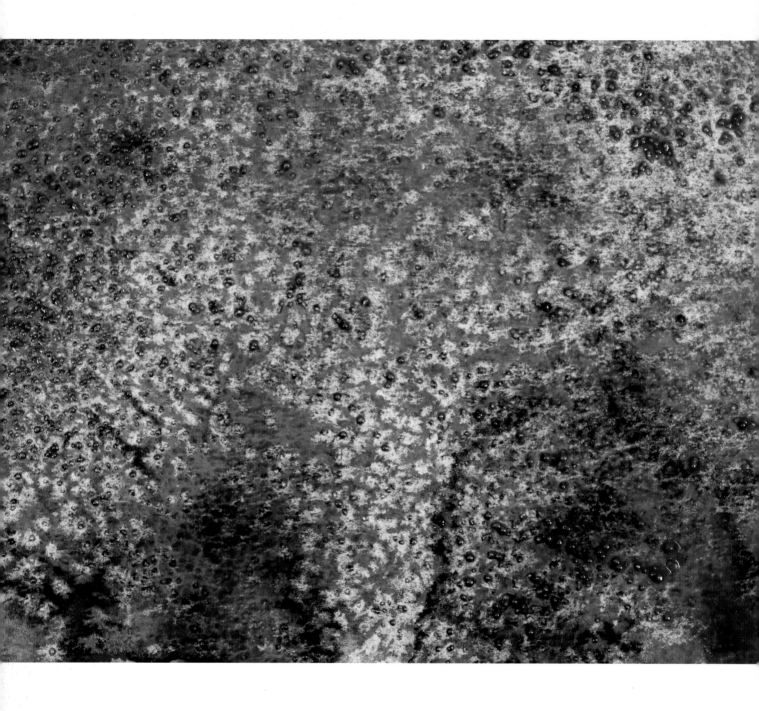

SALT EFFECT

USING A COMMON INGREDIENT FOR A DRAMATIC IMPACT

Watercolorists commonly use granulated salt to create interesting mottled patterns in fluid washes of color, but the results are nonarchival. Because salt is corrosive, it accelerates the oxidation of many pigments and, if left on the surface of a painting, will cause deterioration over time.

Because acrylic paint is water resistant when dry, salt can be applied to fluid acrylic washes and then rinsed off under running water once the paint has dried, leaving the mottled pattern intact and painted surface salt-free.

The effects of this technique vary depending on several factors, including the weight and type of the paper, the choice of pigments, the size of the salt granules, and the amount of salt applied to the surface. Experiment with different colors, surfaces, and types of salt. With the right combination, the outcome can be quite dramatic.

{ MATERIALS }

> ABSORBENT SUPPORT, SUCH AS WATERCOLOR PAPER, AQUABORD, OR PANEL COATED WITH GOLDEN ABSORBENT GROUND
> DISTILLED WATER
> FLUID ACRYLICS
> GRANULATED SALT

Getting Started: Prepare the support. Here, a sheet of 140 lb. cold press watercolor paper is stretched on Homasote board.

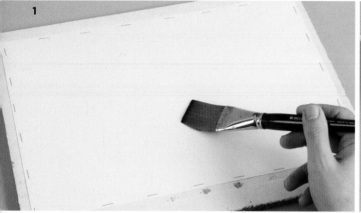

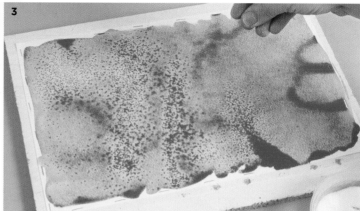

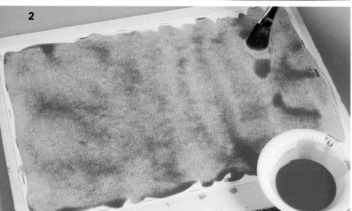

STEP 1: Using a clean soft brush, dampen the paper with an even wash of distilled water.

STEP 2: Apply a liberal wash of fluid acrylic diluted approximately 1:3 with water.

STEP 3: Immediately sprinkle the salt onto the wet surface.

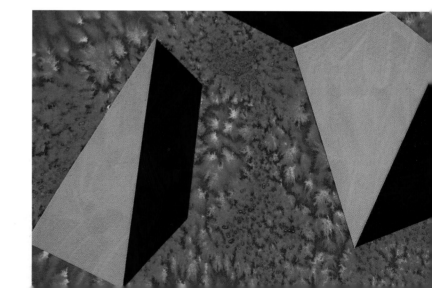

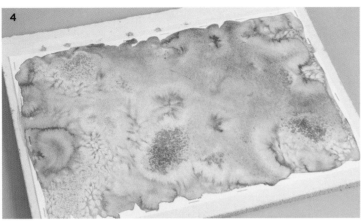

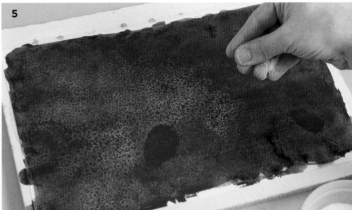

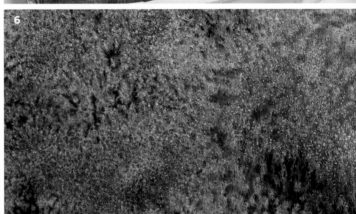

STEP 4: Watch the salt slowly take effect. At first, dark halos of concentrated paint will form around the salt granules. In a few minutes, lighter areas will begin to appear as the salt dissolves into wet areas and displaces the color pigment.

STEP 5: When the sheet is fully dry, try repeating the process. Apply a second wash using a contrasting color and again, sprinkle the salt immediately onto the wet surface.

STEP 6: Once a desirable effect has been achieved and the paint is dry, wash the sheet under running water to remove the salt, and allow the paper to dry fully before removing it from the board. Notice that, after the sheet has been washed, white specks become visible wherever salt granules were stuck to the paper.

Combined Techniques:

Try using the Salt Effect technique in combination with other techniques. Here, it serves as a background to geometric shapes created using the Hard Edge technique.

TECHNIQUES FOR EXPERIMENTING WITH ACRYLIC PAINT

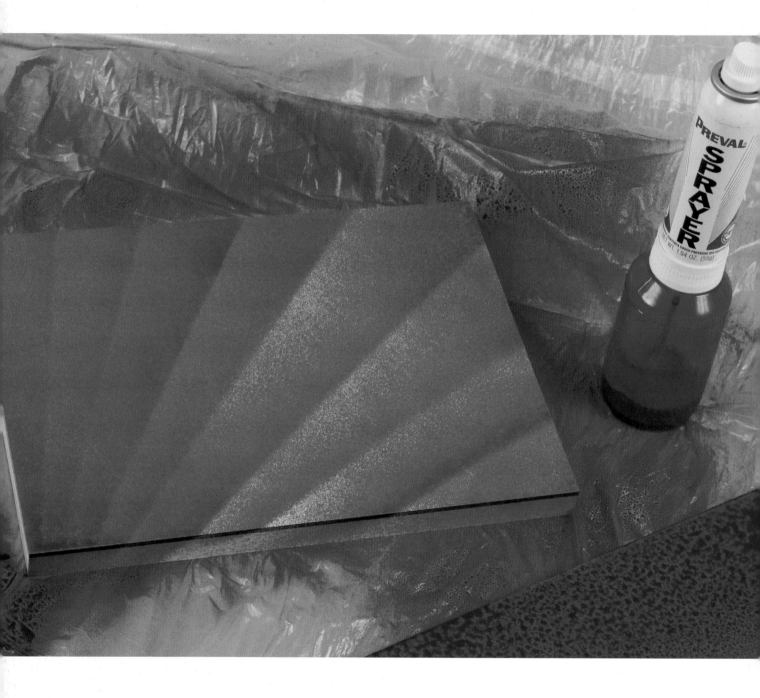

SPRAYING

USING A SOLVENT-FREE ALTERNATIVE TO CONVENTIONAL SPRAY PAINT

Conventional spray paint is highly toxic and should never be used indoors. An airbrush is the best tool for spraying paint in most art applications, but the equipment is expensive and it can be cumbersome for smaller projects.

Unlike airbrushes, Preval sprayers, which are widely available at home centers and art supply stores, are portable and cost less than ten dollars. When used with Golden Airbrush Colors or thinned-down fluid acrylics, the Preval sprayer offers a great solvent-free alternative to conventional spray paint.

Acrylic color can be sprayed at any point in the process of creating an acrylic painting. Try spraying with transparent colors for subtle layer effects, or spattering with opaque colors to create texture. The Preval sprayer also works well for applying solid layers of color over larger areas or for applying a final protective varnish to a finished work.

{ MATERIALS }

> PREVAL SPRAYER
> GOLDEN AIRBRUSH COLORS OR FLUID ACRYLICS AND GOLDEN AIRBRUSH MEDIUM

Getting Started: Almost any well-prepared support will do. Here, a pre-primed Ampersand panel is used.

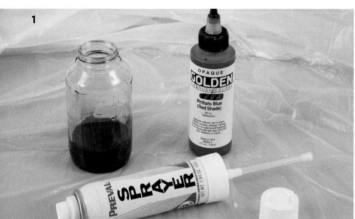

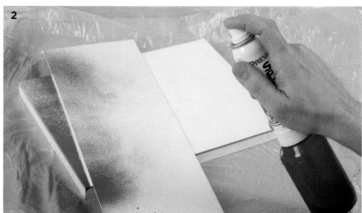

STEP 1: Prepare the work area by spreading a plastic tarp. Fill the sprayer's glass container with paint. Golden Airbrush Colors can be used straight from the jar. Fluid acrylics should be diluted at a ratio of 1:1 with Airbrush Medium.

STEP 2: Use a scrap piece of mat board to mask off an area, and then spray lightly from a distance of 10" to 12" (25.4 to 30.5 cm).

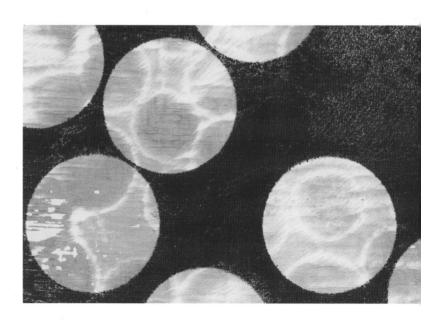

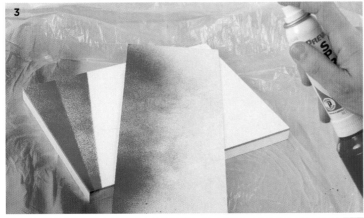

STEP 3: Let the paint dry for a few minutes. Then, reposition the mask and spray again.

STEP 4: Repeat this process until the desired effect is achieved.

Variation:

Spraying can be done at any stage in the making of an acrylic painting. Here, plastic lids were used to mask off circles on a surface created using the Rubbing Alcohol technique. A rust-colored mixture of airbrush colors was sprayed over the surface before the plastic lids were removed.

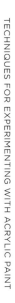

TECHNIQUES FOR EXPERIMENTING WITH ACRYLIC PAINT

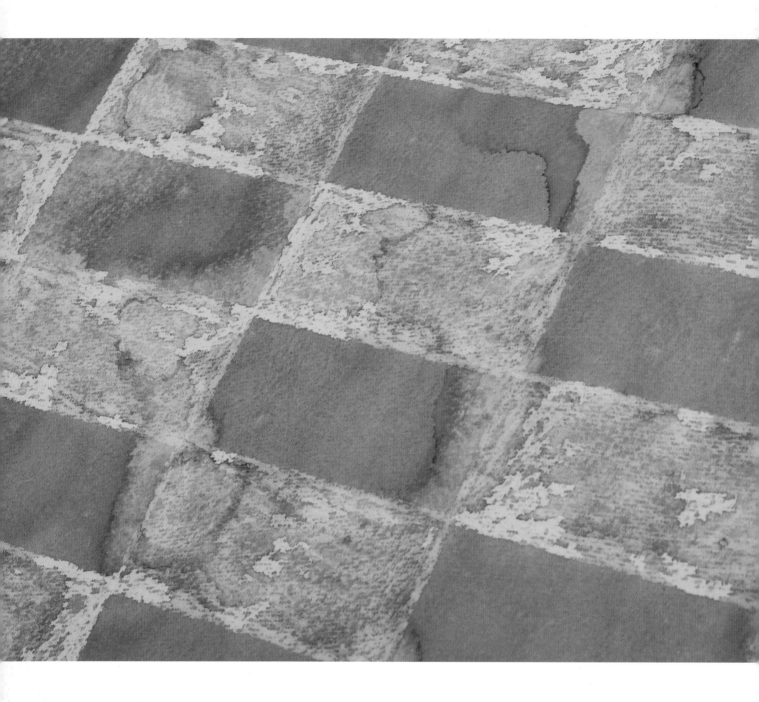

CRAYON RESIST

USING COMMON CRAYONS TO CREATE PATTERNS IN FLUID WASHES OF COLOR

Wax resist is a historical fabric dyeing technique that has been used in many countries for centuries. Essentially, fabrics are drawn upon with molten wax before being immersed in dye solutions, which "resist" being absorbed into the wax embedded portions of the fabric.

Similarly, this technique relies on the idea that the wax in common crayons functions as a resist. When used to create lines or patterns on absorbent paper, the waxy crayon prevents fluid acrylic washes from absorbing into paper, making the pattern visible. This low-tech process is best used with simple shapes, like those traditionally used in batik.

{ MATERIALS }

> WATERCOLOR PAPER
> FLUID ACRYLICS
> DISTILLED WATER
> CRAYONS

Getting Started: White crayons, which can be purchased in bulk, work best for this process. White candlesticks can also be used, but the marks they make are difficult to see.

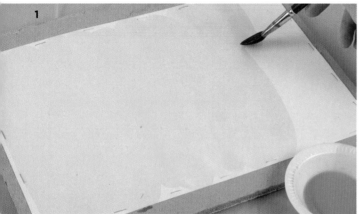

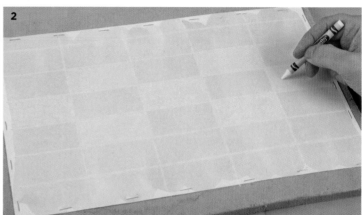

STEP 1: Begin by applying a light-colored wash to a stretched sheet of 140 lb. cold press watercolor paper. Here, Green Gold fluid acrylic is diluted with distilled water at a ratio of 1:4.

STEP 2: Once the surface is fully dry, use a white crayon to dry lines or shapes. Make sure to apply a good deal of pressure with the crayon and build up a very waxy surface.

STEP 3: Using a soft brush, apply a new wash made from a second color. It is important that the wash is highly diluted with water, as a thicker mixture will form a film that will cover the wax.

STEP 4: Repeat the process, applying another wash of diluted color.

Variation:

Crayon Resist works well on panels, too. Here, triangular shapes were taped off and colored in with white crayons. Once the tape was removed, an Ultramarine Blue wash was applied to the entire surface using loose swirling brushstrokes.

SAND SURFACE

CREATING TEXTURE WITH A COMMON MATERIAL

Just about any inert substance can be added to acrylic paints or mediums to create granular surfaces. Golden makes several Pumice Gels (fine, medium, and coarse) for instance, which are particularly useful because they dry to form absorbent surfaces that soak up washes and glazes.

It's also easy to make your own mixtures using common sand, which works well because you can control how much (or how little) to add. For this technique, two different proportions of sand to paint are explored. The addition of a small amount of sand creates just enough texture to catch subsequent layers of glaze, while a greater amount forms a heavy stucco-like texture.

{ MATERIALS }

> SAND
> FLUID ACRYLICS

Getting Started: Because sand will add considerable weight, a rigid support is best here. Both of these examples are done on primed Masonite panels.

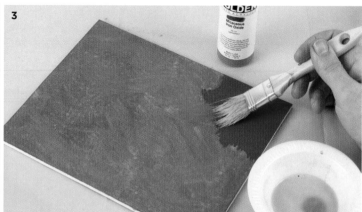

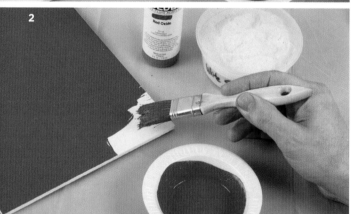

STEP 1: Mix a small amount of sand into a fluid acrylic color. Here, the proportions are about 1:4 and the color is Red Oxide.

STEP 2: Apply the sanded paint with an inexpensive brush, and allow the surface to dry.

STEP 3: Mix a thin colored glaze and apply it to the sanded surface. Here, Micaceous Iron Oxide, Fluid Matte Medium, and water were combined in equal amounts.

VARIATION

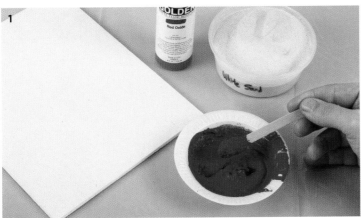

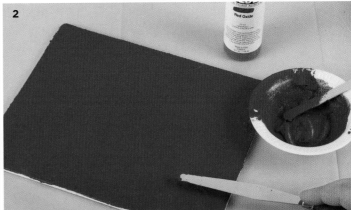

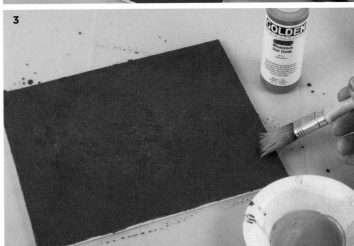

STEP 1: Mix a greater amount of sand to fluid acrylic color. Here, the proportions are about 3:1, with a very small amount of water added to help keep the mixture spreadable. It is important that the mixture contains enough paint that when it's dry, it binds the sand. Too much water will make the paint film weak and brittle, and the sand mixture will become crumbly.

STEP 2: Apply the thick sand/paint mixture to a primed panel using a palette knife, and allow the surface to dry.

STEP 3: Apply a thin glaze to the surface (as done in step 3, page 72).

Variation:

Here, sand was added to Titanium White fluid acrylic and applied to taped off stripes using the Hard Edge technique.

TECHNIQUES FOR EXPERIMENTING WITH ACRYLIC PAINT

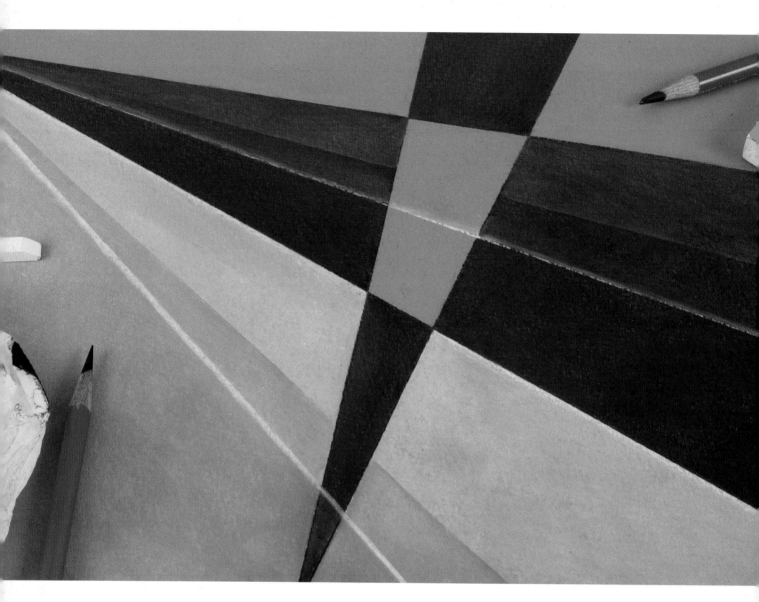

ACRYLIC AS GROUND FOR CHARCOAL AND PASTEL

USING ACRYLIC TO CREATE *TOOTHY* SURFACES

Papers for charcoal and pastel are commonly available in a wide array of colors. But it is easy to create your own drawing surface for charcoal and pastel using matte acrylic colors, which can be applied to a wide range of supports.

Drawing papers are formulated to have the right texture (or "tooth") to hold marks made with charcoal and pastel. Painted surfaces are generally too smooth or slick. But matte acrylics are formulated with matting agents that make them dry to a toothy surface that the finely ground pigments in charcoal and pastel can grab onto.

Golden also makes an Acrylic Ground for Pastels, which is clear and matte, and can be applied over almost any kind of acrylic basecoat, even a glossy one. It can also be used to prepare a support that is not normally considered to be ideal for drawing, such as a Masonite panel.

{ MATERIALS }

> MATTE FLUID ACRYLICS OR HEAVY BODY MATTE ACRYLICS
> DISTILLED WATER
> CHARCOAL AND/OR PASTELS
> ACRYLIC GROUND FOR PASTELS

Getting Started: Golden makes Matte Fluid Acrylics and Heavy Body Matte Acrylics, both of which work well for this technique.

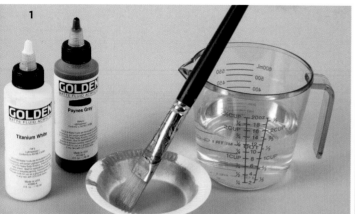

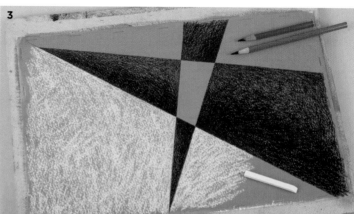

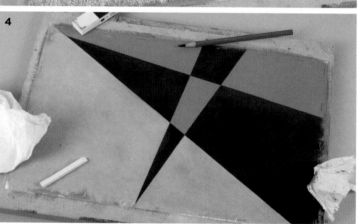

STEP 1: Using Matte Fluid Acrylics, dilute 1:1 with distilled water to make a colored wash. Heavy Body Matte Acrylics should be diluted 1:2 with distilled water.

STEP 2: Apply 2 or 3 coats of the colored wash to a sheet of stretched paper, allowing each coat to dry before applying another. Here, the paper is 140 lb. cold press watercolor paper, and the wash is made from a mixture of Paynes Gray and Titanium White Matte Fluid Acrylics.

STEP 3: Use this surface to draw on with charcoal and pastel, allowing the base color to remain visible as part of the final image.

STEP 4: Use paper towels, blending stumps, and erasers as needed to blend the charcoal and pastel. Using this approach, underpainting with color washes of matte acrylic can serve as an integral part of a finished drawing.

VARIATION

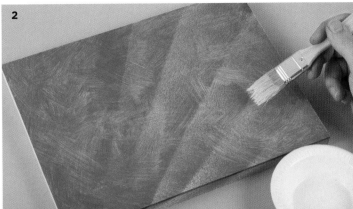

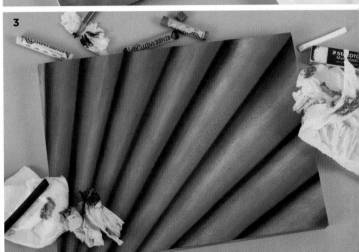

STEP 1: Mix Golden Acrylic Ground for Pastels by diluting up to 40 percent with distilled water.

STEP 2: Use the mixture to coat a support that already has some paint applied to it, or one that is not normally well suited for drawing. Here, an Ampersand panel has been sprayed with Golden Airbrush Colors using a Preval sprayer (see page 62). Apply two coats, allowing the first to dry fully before applying the second.

STEP 3: Once it is dry, draw on the surface with charcoal and pastel.

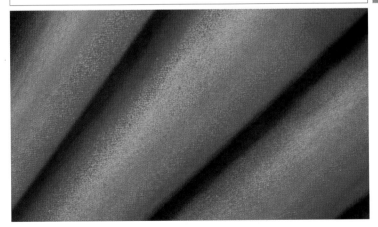

[CLOSE-UP VIEW]

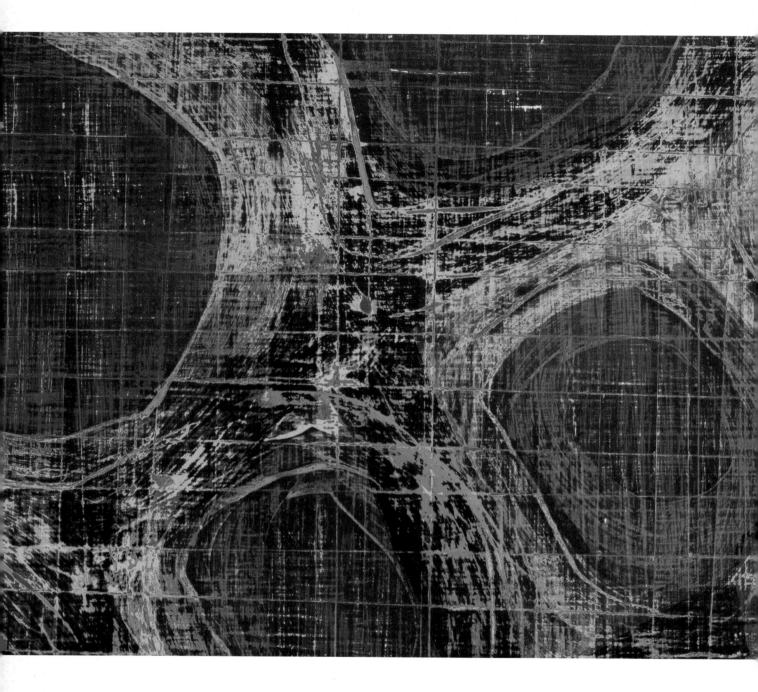

SGRAFFITO

UNEARTHING LAYERS BELOW

The ancient technique known as *Sgraffito*, which literally means "to scratch," has been used for centuries in ceramics and painting. The idea is that a topcoat is scratched through to reveal color below. Adapted to acrylic painting, the process of scraping or sanding through a topcoat allows for somewhat unpredictable results that can be very exciting as strange color juxtapositions emerge and rich textures take form.

{ **MATERIALS** }

> EXISTING PAINTING ON A RIGID SUPPORT
> FLUID ACRYLICS AND/OR HEAVY BODIED ACRYLICS
> SANDING SPONGE

Getting Started: This version is best applied to a surface that has been somewhat built up with painted shapes. Hard-edge shapes work particularly well, as their raised edges sand off easily. Consider using it on an existing painting that didn't work out, or start a new painting by freely building up layers of simple shapes and patterns that will be covered with new layers that will be scraped through.

DRY VERSION

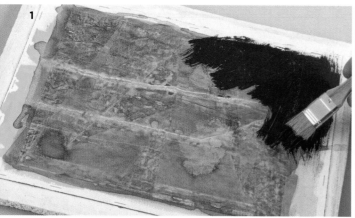

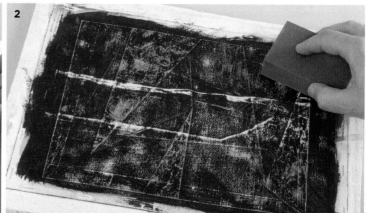

STEP 1: Make sure the surface of the painting is dust-free, wiping it with a damp cloth if necessary. Apply a fresh coat of fluid acrylics, using colors and/or values that stand in contrast to the base painting.

STEP 2: Once the paint is fully dry, begin to sand the surface using a medium- or fine-grit sanding sponge. Try varying the amount of pressure used. Depending on how aggressively the surface is sanded, varying amounts of the layers below will be revealed. Be careful not to sand all the way through to the support.

Getting Started: Scraping into wet paint is a common method used to create textural surfaces or fine lines. Palette knives work well, as do wooden skewers, toothpicks, and many other found tools.

WET VERSION

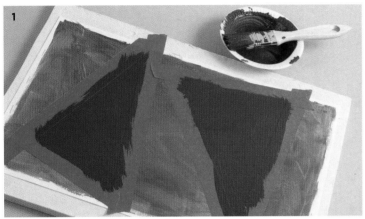

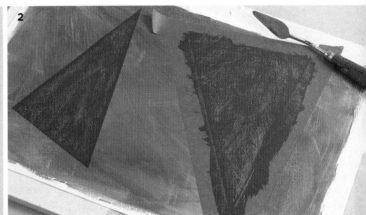

STEP 1: Depending on the desired effect, apply either fluid or heavy bodied acrylic to a previously painted area, using contrasting colors and/or values. Heavy bodied paints will tend to hold sharper lines. To create crisply defined shapes, use this technique in conjunction with the Hard Edge technique (see page 39).

STEP 2: Immediately work into the wet layer of paint. Scrape a palette knife across the wet surface to reveal raised areas below, or scribe new lines with a toothpick or skewer.

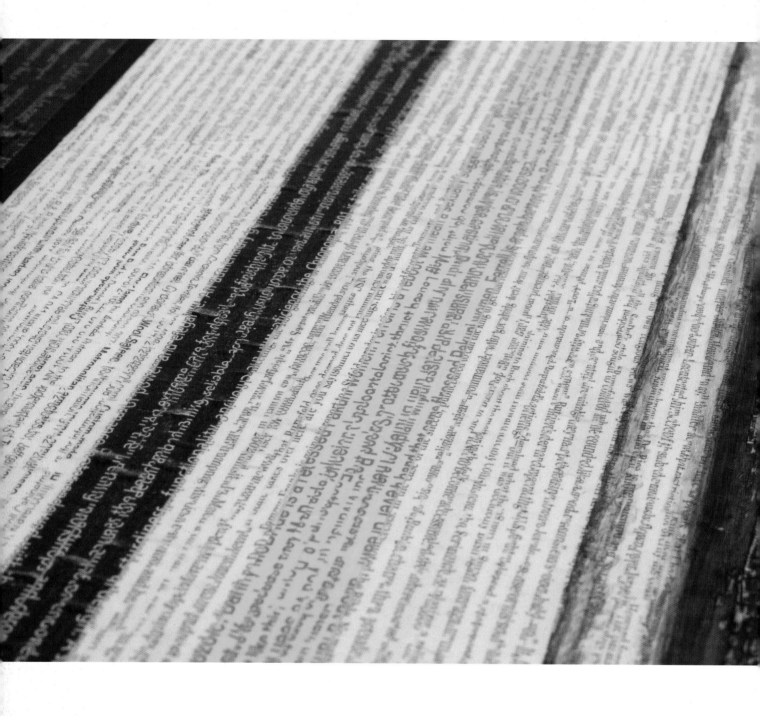

TEXT AS TEXTURE

USING NEWSPAPER AND MAGAZINE TEXT TO CREATE TEXTURAL SURFACES

Collage has been a mainstay of modern art for about a hundred years, since Picasso and Braque coined the term in the early part of the twentieth century from the French word for glue, *colle*. While some early modernists used collage as a way to reference popular culture, the technique is equally valuable as a way to simply build images and surfaces.

For this technique, text from magazines and newspapers is cut into strips and used to create blocks of visual texture. To get away from the literal meaning of the words, lines of text can be cut in half lengthwise, obscuring their readability. Seeing the resulting textures, the possibilities are infinite for the kinds of images that can be created.

{ MATERIALS }

> MAGAZINES OR NEWSPAPERS
> FLUID MATTE MEDIUM

Getting Started: Look for a variety of font styles and sizes as well as colors of type and paper. Collect an assortment.

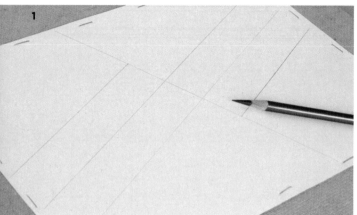

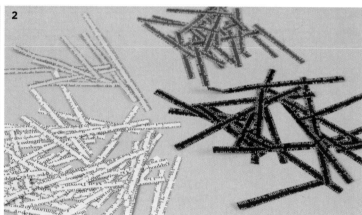

STEP 1: Use a pencil to sketch out a basic composition.

STEP 2: Cut strips of text and accumulate piles of similar styles and colors.

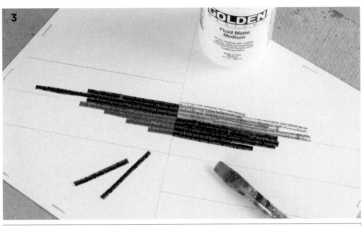

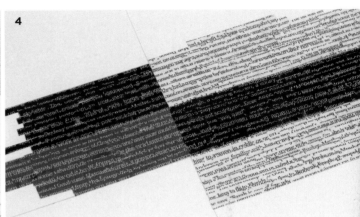

STEP 3: Apply a light coat of Fluid Matte Medium to a small portion of the support. Paste a single strip of text into the wet medium. Apply a light coat over the text, and move on to the next strip. Try not to coat too large an area at once, as fluid medium dries fast.

STEP 4: Continue to build shapes from the strips of text until the composition is complete. Consider working into some portions with fluid acrylics, glazes, or other techniques.

Variation:

Pages from an old book with yellowed pages were used for the text strips here, alongside others strips cut from newer magazines.

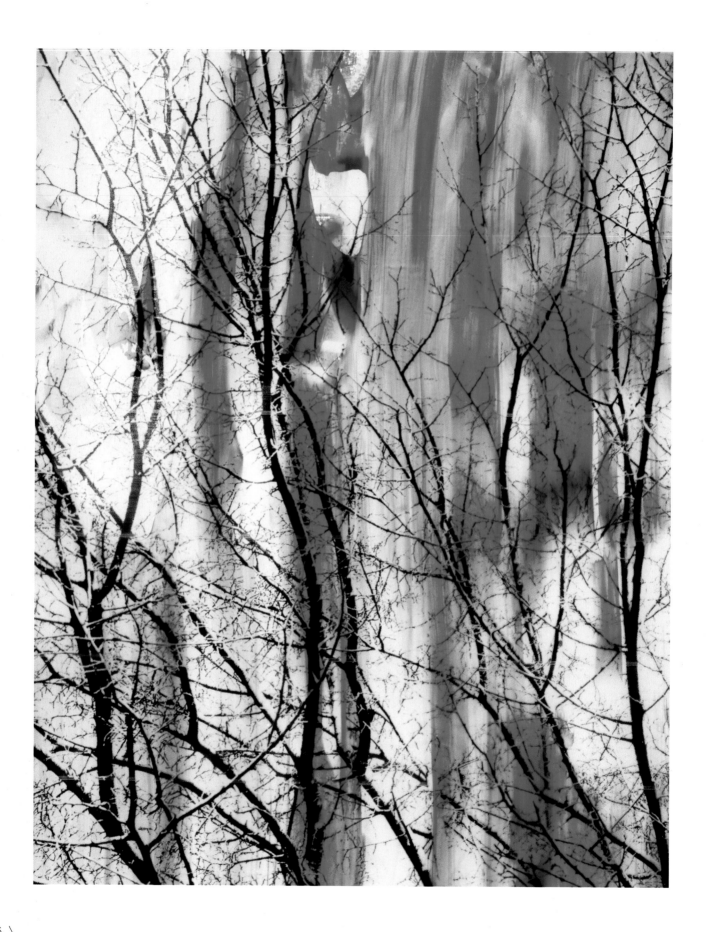

DIGITAL GROUND

USING DIGITAL GROUND TO PRINT ON ACRYLIC SKINS

Although a range of commercial fine art papers can be used in ink-jet print-ers, a new line of liquid mediums allow artists to transform an enormous range of papers and other materials into printable surfaces. Golden Digital Ground is available in three formulations: Clear (Gloss), White (Matte), and Digital Ground for Non-Porous Surfaces. This technique uses Clear (Gloss)—the best choice for printing over acrylic paint—applied to an acrylic skin.

Printed skins can be used in many ways. To adhere them to stretched canvas, a panel, or other support, use Soft Gel or Fluid Matte Medium as an adhesive. Skins can be folded, twisted, stretched and pulled, or used to make three-dimensional forms. To store them, sandwich them between sheets of wax paper. They will remain pliable indefinitely.

Keep in mind that ink-jet ink remains water soluble when dry. Before using printed skins as collage material or applying subsequent layers of paint or medium to any ink-jet image, treat it first with a spray fixative, such as Golden Archival Varnish.

{ MATERIALS }

> FREEZER PAPER OR PLASTIC SHEETING
> PAINTER'S TAPE
> FLUID ACRYLICS
> SELF LEVELING CLEAR GEL OR OTHER FLUID MEDIUM
> DIGITAL GROUND CLEAR (GLOSS)
> PRINTER PAPER
> STANDARD INK-JET PRINTER

Getting Started: Choose an image to print. Although full-color images may be used, because ink-jet colors are transparent, they only show up well against very light-colored skins. Using standard printing paper, experiment with different ways to manipulate an image. Very high-contrast black-and-white images tend to work best for this technique.

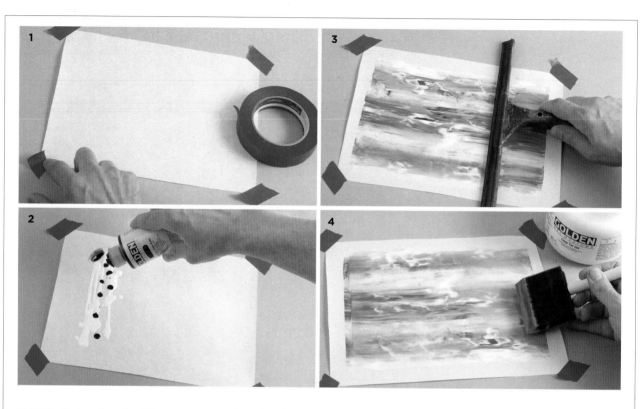

STEP 1: Cut a sheet of freezer paper (or plastic sheeting) and tape it down to a smooth, flat surface with painter's tape. Keep in mind that in order for the dry skin to pass through a standard ink-jet printer, it can be no larger than an 8½" x 11" (21.6 x 27.9 cm) sheet of printer paper.

STEP 2: Begin to apply fluid acrylic colors directly to the freezer paper. Remember that the skin will serve as a background to the image printed on top of it. Use some light colors (or white) so that black ink from the ink-jet printer will be visible against this background.

STEP 3: Using a squeegee, gently spread the paint evenly across the freezer paper. Without pressing down too hard, skim the surface several times to distribute the color and create an even film. This may take some practice.

STEP 4: Once the paint is fully dry, check for voids in the paint film. If needed, use a foam brush to apply a layer of clear medium to fill voids and create a smooth, unbroken surface. Self Leveling Clear Gel, Polymer Medium, and Clear Tar Gel all work well for this purpose. Allow the medium to dry fully before proceeding.

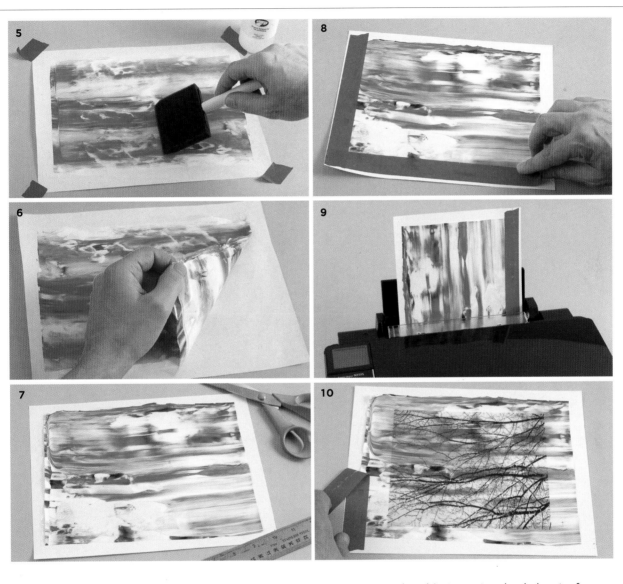

STEP 5: Apply a minimum of 2 coats of Digital Ground Clear Gloss. Allow each coat to dry before applying another. Apply in alternating directions to ensure an even surface.

STEP 6: Once the coated skin is dry, carefully separate it from the freezer paper.

STEP 7: If necessary, use scissors to trim the skin down to a size no larger than 8″ x 10½″ (20.3 x 26.7 cm).

STEP 8: Tape the skin to a standard sheet of printing paper along the top and left-hand sides of the skin.

STEP 9: Feed the sheet into the printer. Print the image.

STEP 10: Remove the tape.

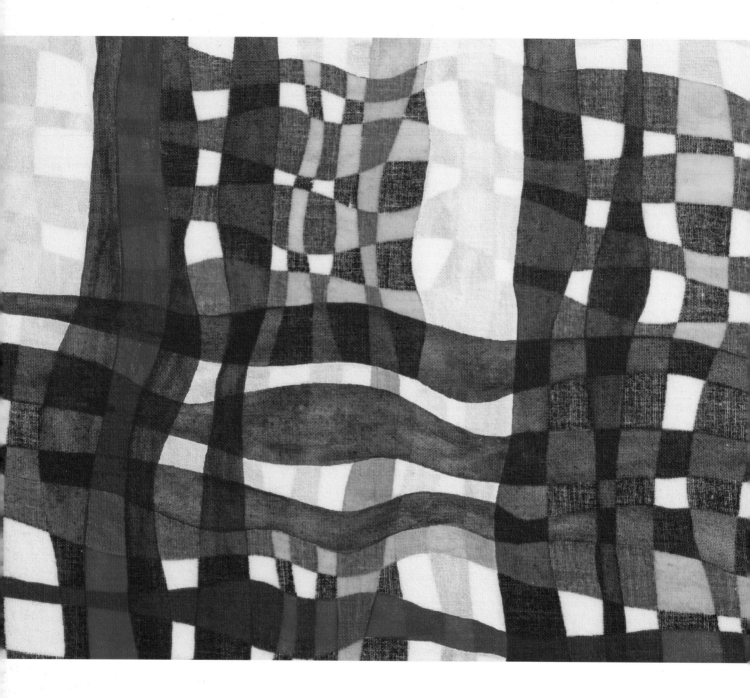

PATTERNED FABRIC

GETTING A HEAD START USING EXISTING PATTERNS

There is no rule that says a painting must begin with a blank canvas. Patterned fabrics can offer a great starting point, especially those with relatively sparse patterns. Look for lightweight cotton prints, which adhere well to supports and are easy to handle.

{ MATERIALS }

> PRINTED FABRIC (COTTON OR COTTON BLEND)
> PREMADE SUPPORT (STRETCHED CANVAS OR PANEL)
> SOFT GEL MATTE (MEDIUM)
> FLUID ACRYLICS
> DISTILLED WATER

Getting Started: Look for fabrics with patterns that can be worked into. Heavier cotton fabrics can be stretched just like raw canvas, but lightweight cotton prints are best mounted to an existing support.

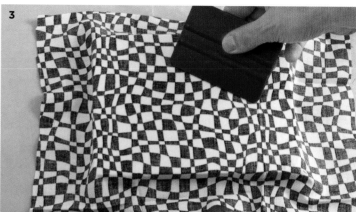

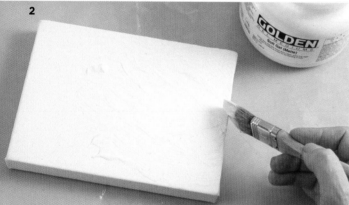

STEP 1: Cut a piece of fabric so that it is large enough to cover your chosen support. Leave enough excess to wrap around the edges.

STEP 2: Brush a generous amount of Soft Gel Matte on the support, evenly covering the entire surface and the edges.

STEP 3: Adhere the fabric to the support. Starting in the center and working out, lightly burnish the surface using a burnishing tool or a stiff piece of cardboard.

Tip:

When looking for fabrics to paint on, consider patterns and colors that correspond to your own visual sensibilities.

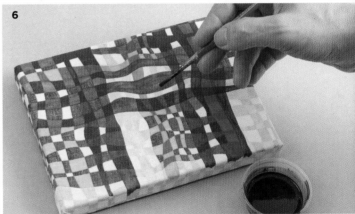

STEP 4: Adhere the edge of the fabric on the back-side of the support. Use staples to hold the loose fabric in place.

STEP 5: Flip the support back upright and allow it to dry fully.

STEP 6: Once dry, paint into the fabric using fluid acrylics diluted 3:1 with distilled water or use any other technique to build up the surface.

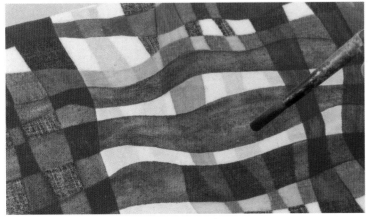

[CLOSE-UP VIEW]

TECHNIQUES FOR EXPERIMENTING WITH ACRYLIC PAINT

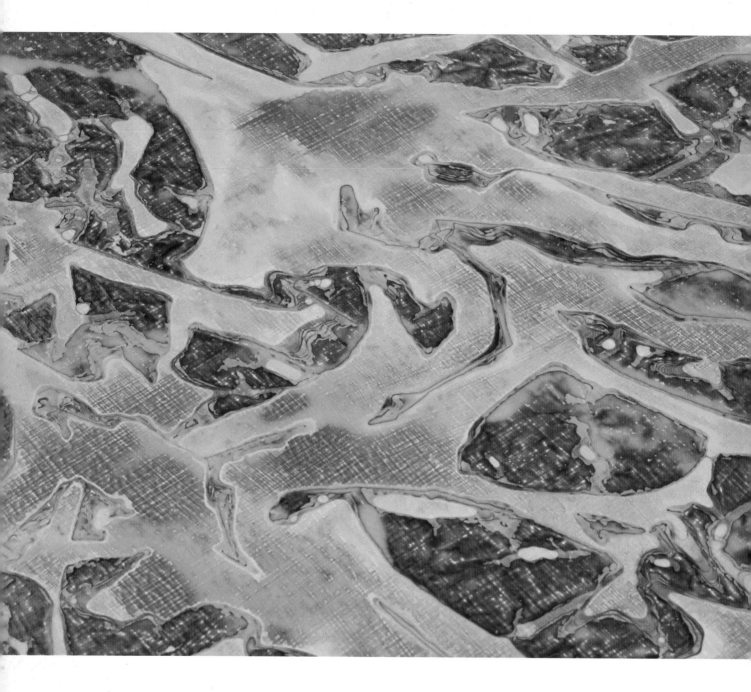

CELLOPHANE TEXTURE

CREATING A JAGGED IMPRESSION

Cellophane has a unique way of holding wrinkles. When placed over a watery paint surface, it displaces the paint and leaves an impression of jagged, angular shapes. The resulting texture can become the foundation for any number of subsequent treatments. Try adding washes and glazes to build up complex layers of color.

{ MATERIALS }

> FLUID ACRYLICS
> DISTILLED WATER
> CELLOPHANE ·

Getting Started: This technique only works on a flat, level surface and on a rigid support, such as a panel or gessoed paper stretched on a board. If the work area is not level, the watery paint will run to one side of the panel. Use a level, along with craft sticks or scraps of cardboard, to level the support.

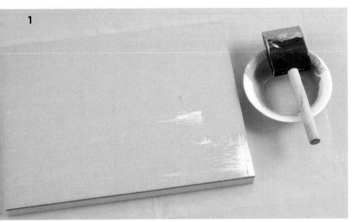

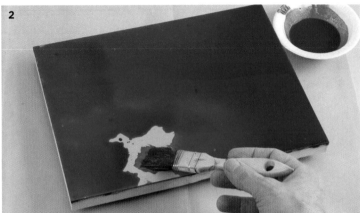

STEP 1: Apply a basecoat using fluid acrylics.

STEP 2: Once the basecoat is fully dry, apply a second coat of fluid acrylic diluted 1:2 with water. Use a contrasting color and/or value.

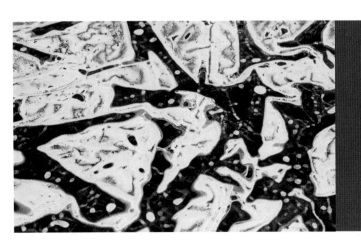

Variation:

For this surface, a watery wash of Titanium White was used over a basecoat of Carbon Black.

3

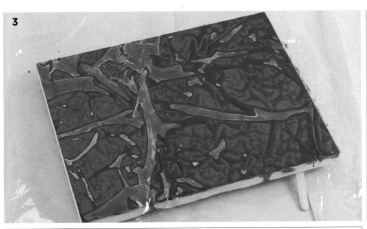

4

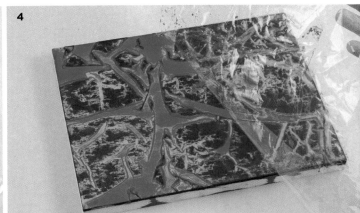

STEP 3: Immediately place a crumpled sheet of cellophane on the wet paint. Make sure it is partially touching the entire surface area, and leave it in place overnight.

STEP 4: Check to see if the surface beneath the cellophane is dry. Once it is, peel the cellophane off.

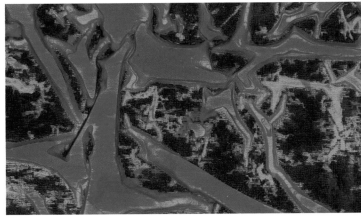

[CLOSE-UP VIEW]

RUBBING ALCOHOL

CAUSING A CHEMICAL REACTION

Various household chemicals have an interesting effect on acrylic paint, especially in its wet state. Among them is isopropyl (rubbing) alcohol, widely available at drugstores in two different strengths. For this technique, the stronger one (91%) works best.

When alcohol from an eyedropper hits wet acrylic paint, it disrupts the surface tension of the fluid paint, displaces the pigment, and leaves an interesting mark that remains intact as the surface dries. Repeated drops, spread more-or-less evenly across a flat surface, create an appealing pattern. Try experimenting with different color combinations for the basecoat and topcoat, and try using this technique over or under other techniques, such as the Salt Effect technique on page 59 or the Sgraffito technique on page 79.

Because this technique causes separation between the paint's pigment and binder, a final coat of fluid medium or varnish should be applied to ensure adhesion and durability.

{ MATERIALS }

> FLUID MATTE MEDIUM
> FLUID ACRYLICS
> DISTILLED WATER
> ISOPROPYL ALCOHOL
> EYEDROPPER

Getting Started: This technique can be done on almost any support, but smooth surfaces work best. Keep in mind that it can be used at any stage with an in-progress painting. Here, hard-edge shapes are taped off over a surface that was created using the Sgraffito technique (see page 79) on 140 lb. watercolor paper.

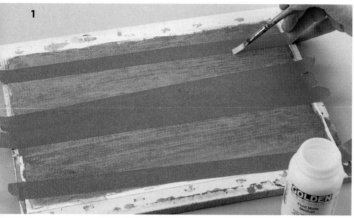

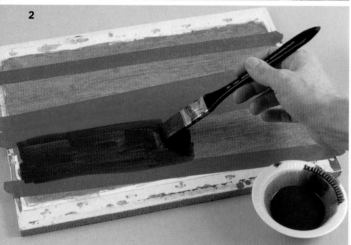

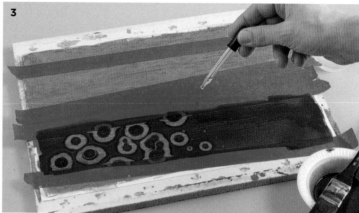

STEP 1: Tape off desired areas and seal the edges of the tape with fluid medium. Apply two coats, allowing the first to dry before applying the second.

STEP 2: Prepare a mixture of fluid acrylic and distilled water (about 1:1), and apply it sparingly to one of the taped-off shapes. Do not cover too large an area, because the paint must be wet in order for the alcohol effect to work properly.

STEP 3: Use an eyedropper to apply drops of alcohol to the wet paint surface. Notice how the shapes spread outward.

NOTE: Although it is safer than many other solvents, isopropyl alcohol is flammable and should not be inhaled. Use it in a well-ventilated area and away from open flames.

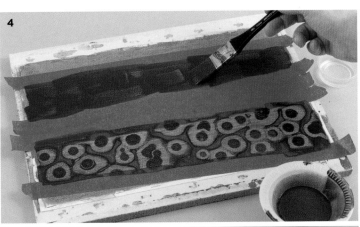

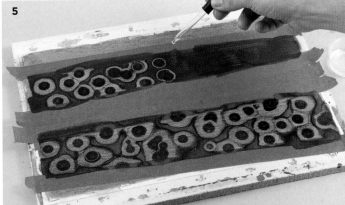

STEP 4: Once the first shape is completed, move on to the next shape. Again, do not coat too large an area. The alcohol must be applied to wet paint.

STEP 5: Apply alcohol drops to the wet surface. Once all the shapes have been treated, leave the tape in place and allow the paint to fully dry.

STEP 6: Once the surface is dry, remove the tape.

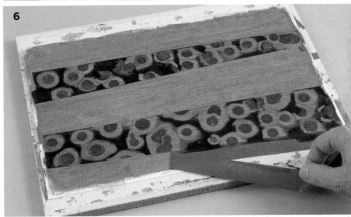

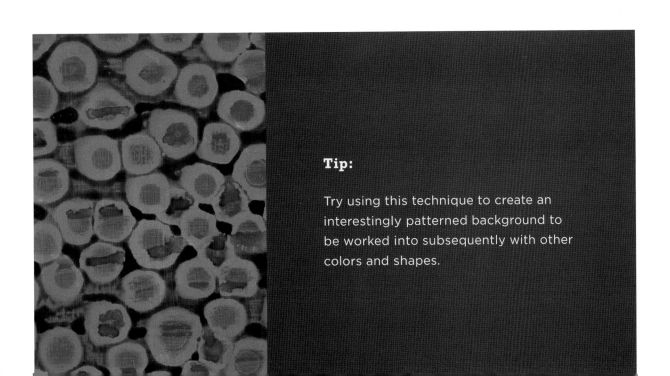

Tip:

Try using this technique to create an interestingly patterned background to be worked into subsequently with other colors and shapes.

TECHNIQUES FOR EXPERIMENTING WITH ACRYLIC PAINT

/ 101

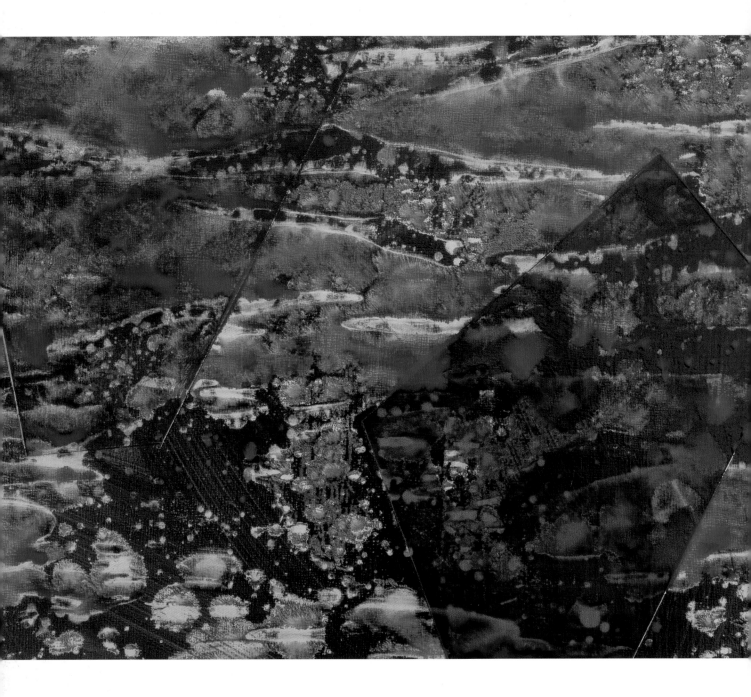

BLOTTING

CREATING TEXTURES BY PARTIALLY REMOVING PAINT WITH WATER AND NEWSPRINT

One of the great benefits of acrylic paint being water-based is that it can be manipulated without the use of solvents. Until it is dry, it remains water-soluble. This technique takes advantage of acrylic's solubility, using water and newsprint to lift a portion of a paint surface in order to create interesting textures. Try using it with a variety of colors to create multiple, overlapping layers.

{ MATERIALS }

> NEWSPRINT
> FLUID ACRYLICS

Getting Started: Gather a generous amount of newsprint (or actual newspaper) and position it near the surface to be treated.

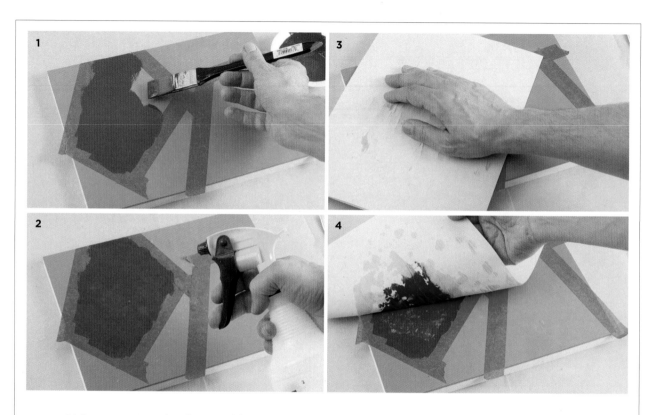

STEP 1: Using a contrasting hue and/or value, apply an even coat of fluid acrylic to a support that already has at least one coat of paint on it. To create textures within hard-edge shapes, use the Hard Edge technique on page 39.

STEP 2: Allow the newly applied paint to sit for a minute or two, just until its sheen begins to dull. Using a spray bottle, apply a small amount of water to the desired portion of the painting. Be sure not to completely drench the entire surface.

STEP 3: Let the water sit on the dampened paint for a minute or two, and then blot the surface with a sheet of newsprint. Keeping it in one place, rub the surface of the newsprint with one hand to ensure full contact with the paint surface.

STEP 4: With one swift motion, remove the newsprint. Allow the paint to dry fully and then continue treating individual shapes.

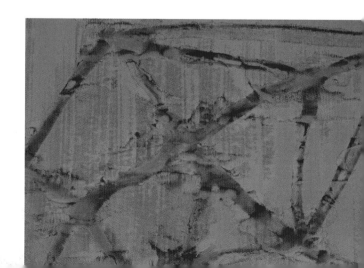

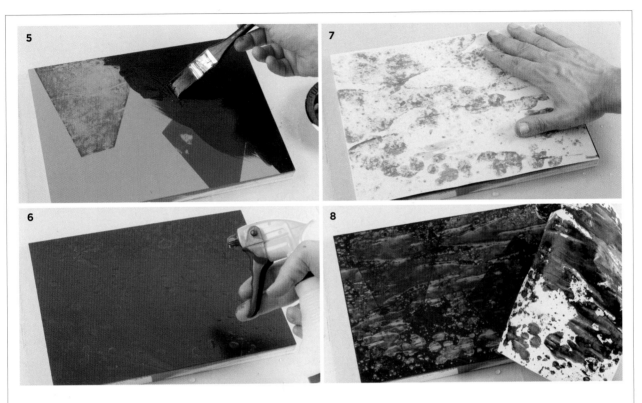

STEP 5: Once all individual shapes are complete, apply a new layer of fluid acrylic in a contrasting color and/or value to the entire surface.

STEP 6: Use a spray bottle to apply a small amount of water to the surface.

STEP 7: Let the water sit for a minute or two, and then blot the surface with newsprint.

STEP 8: Remove the newsprint.

Variation:

Instead of applying water with a spray bottle, try using a brush to create wet lines. Here, a light blue coat of fluid acrylic was applied over a dry basecoat of Red Oxide. Wet lines were then brushed loosely and the entire surface was immediately blotted, lifting the blue off the wet areas and revealing the Red Oxide below.

TECHNIQUES FOR EXPERIMENTING WITH ACRYLIC PAINT

/ 105

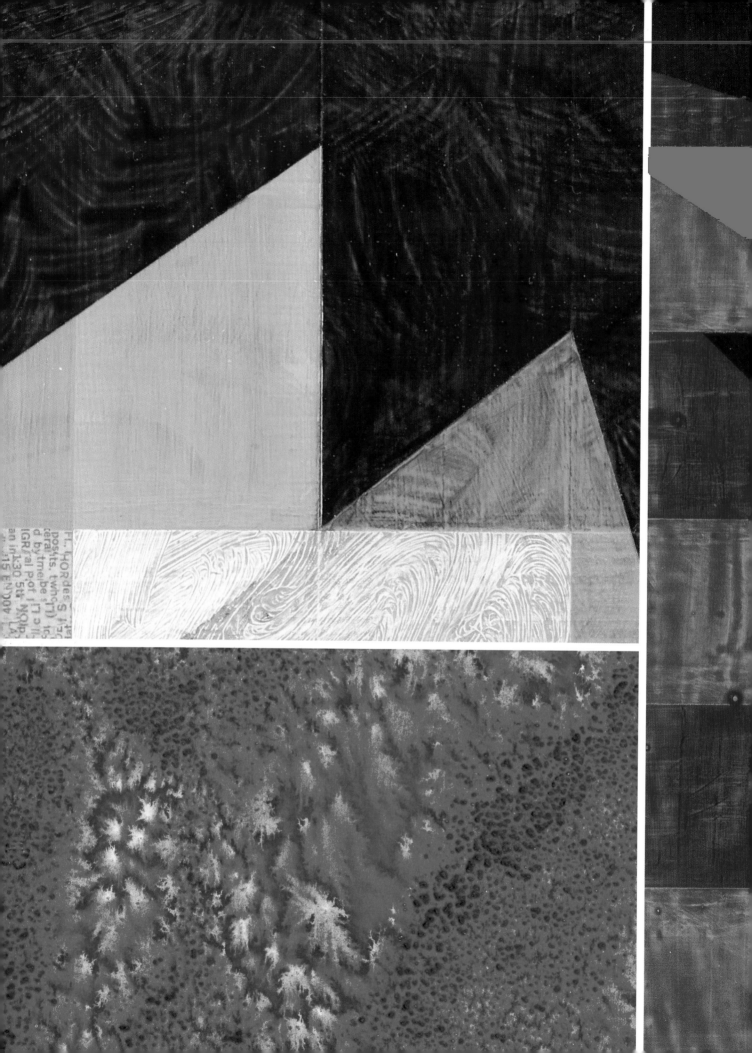

GALLERY

3

This section highlights examples of experimental techniques put to good use, and shows some possible ways of using them in combination with one another. *Fusion*, after all, is the process of joining two or more things together to form a new whole. Whether those things are materials or techniques, a fusion has the potential to create an exciting dynamic of new possibilities.

Used alone or together, the techniques demonstrated here are, in a sense, filtered through the author's personal, ongoing studio practice. Try adapting them to fit your own ideas, interests, and aesthetic sensibilities. Given the remarkably diverse properties of acrylic paints and mediums, the possibilities truly are endless.

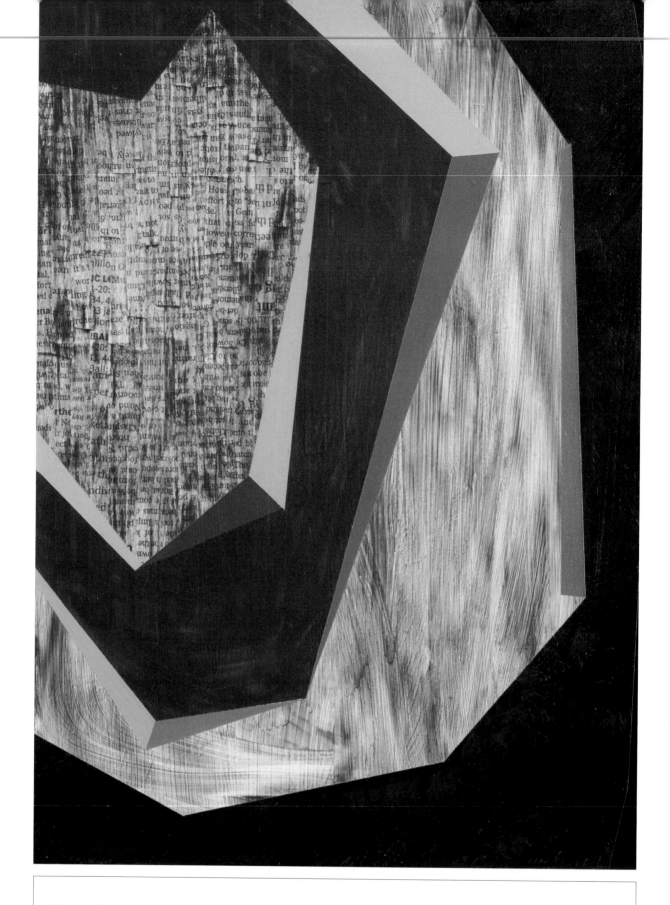

Strips of text were cut from a magazine and adhered to a primed panel using Fluid Matte Medium. The whole surface was then brushed loosely with a Yellow Ochre glaze. Hard-edge shapes were taped off and painted with straight fluid color. A blue glaze was applied over a Burnt Sienna base to form the darker background area.

The Sgraffito, Blotting, and Hard-Edge techniques were combined here using a severely limited color palette and minimal shapes, highlighting subtle shifts in the textural surfaces.

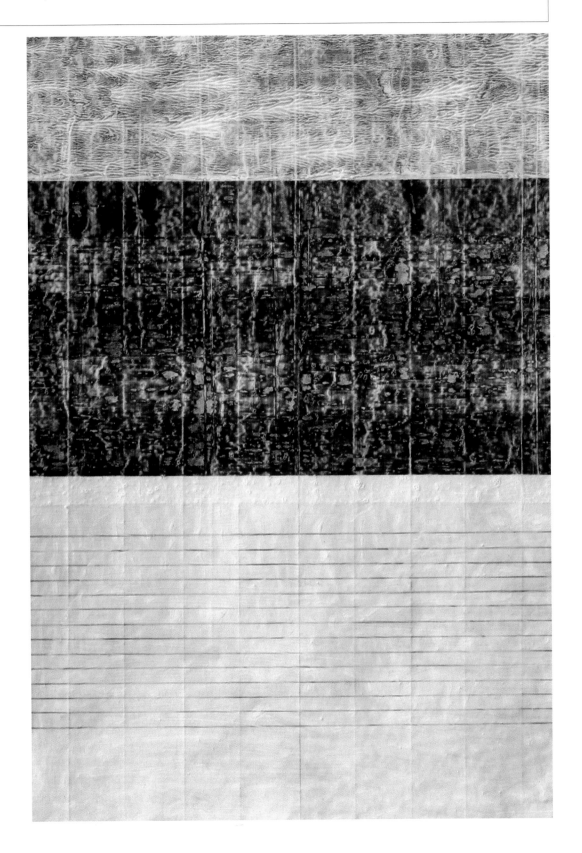

Cut strips of text were glued down using Fluid Matte Medium to create the textural column on the left, while the triangular shapes on the right were taped off and brushed with fluid color. Several layers of colored glaze were applied, each of which was scraped with a palette knife while the glaze was still wet. The vertical blue areas were applied last, and were scraped lightly with a palette knife to reveal some of the color below.

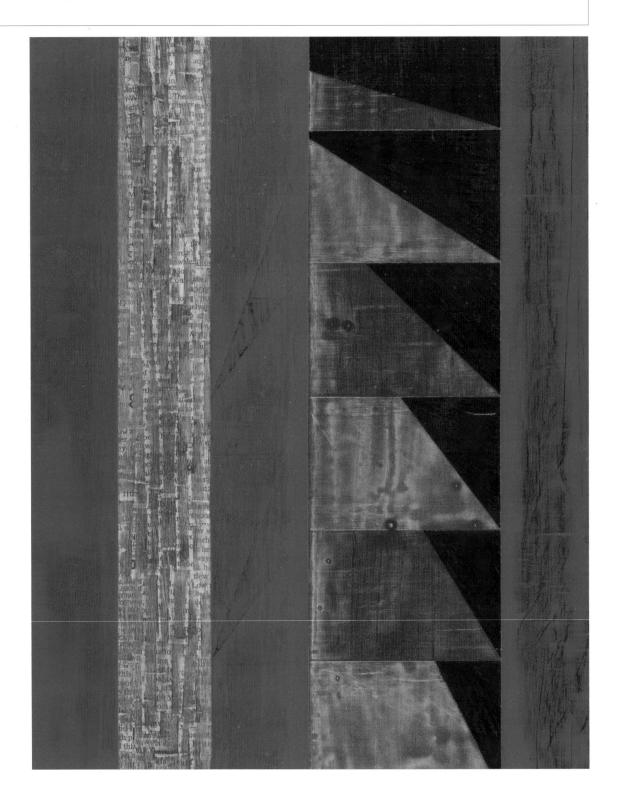

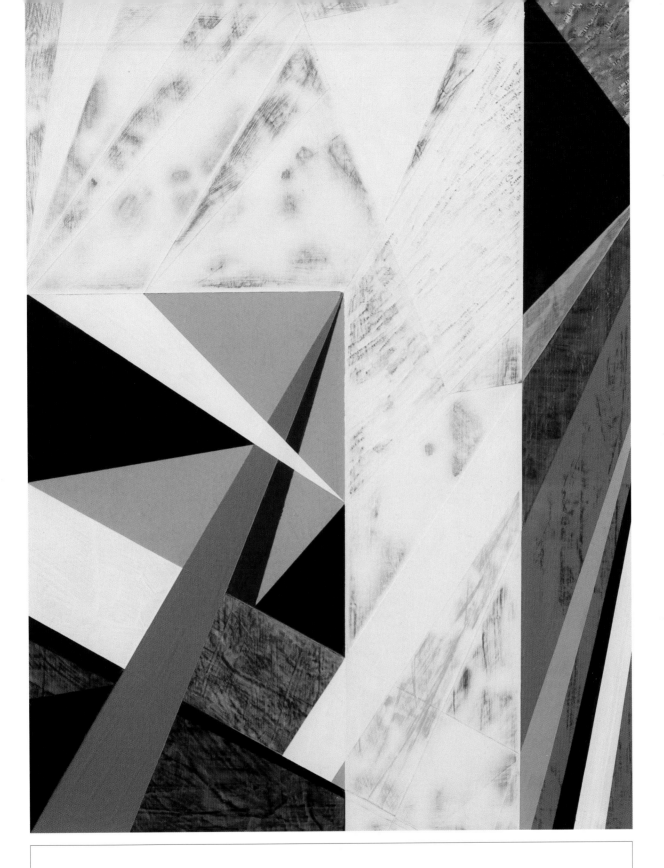

A combination of straight fluid acrylics and glazes were used within taped-off shapes to create this composition. In some areas, the wet glaze was scraped with a palette knife while the glaze was still wet, revealing the color below. For the large central white area, a translucent mixture of Titanium White, Fluid Matte Medium, and water was applied to the surface within a taped-off shape and allowed to dry before the tape was removed.

Heavy bodied acrylic was used to create the swirling textural surface on the white rectangle in the center of this piece. Fluid colors were used for the base layers of the other shapes, which were first taped off and then sealed with Fluid Matte Medium. Strips of collaged text fill one rectangular area on the left side. Several colored glazes were applied to various taped-off areas, the last of which was a dark brown glaze that formed what appears as the background.

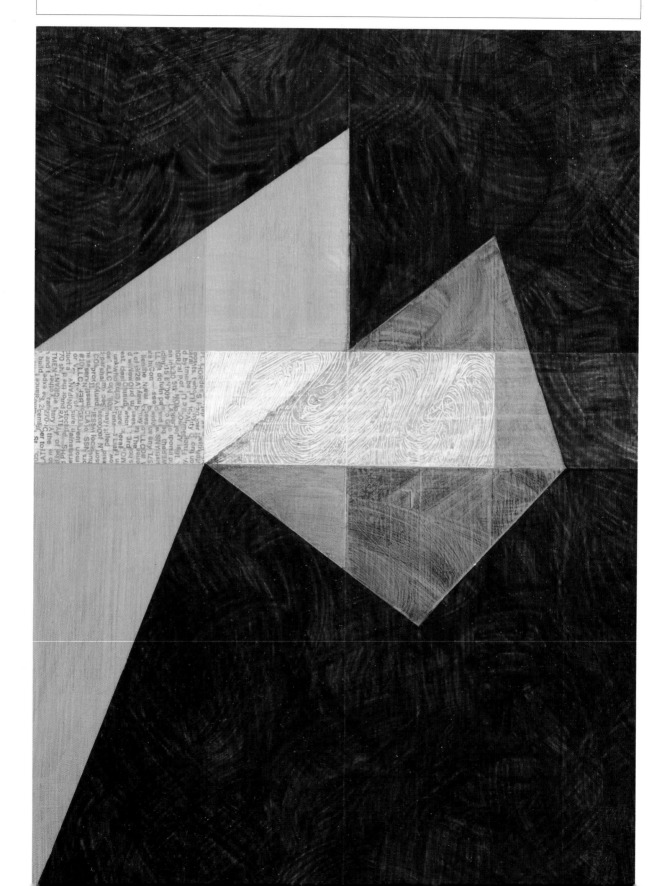

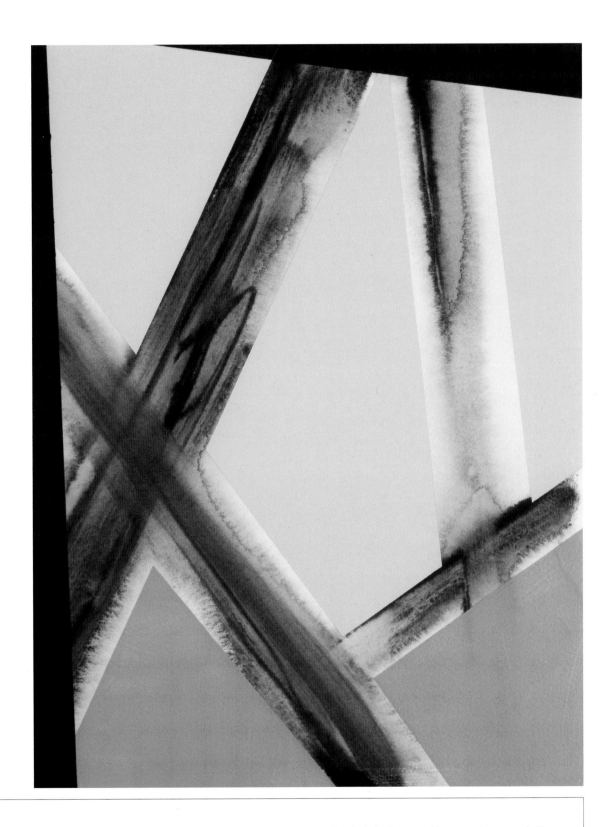

This piece was done on 140 lb. watercolor paper stretched tightly on a Homasote panel. For the first layer, black fluid acrylic lines were applied with a brush on very wet paper. Once the paper was dry, hard-edge shapes were taped off and painted with solid color.

Unlike oil, acrylic paint can be applied directly to raw, unprimed canvas. Here, canvas was dampened with water. Then, various color washes were freely applied to the damp surface.

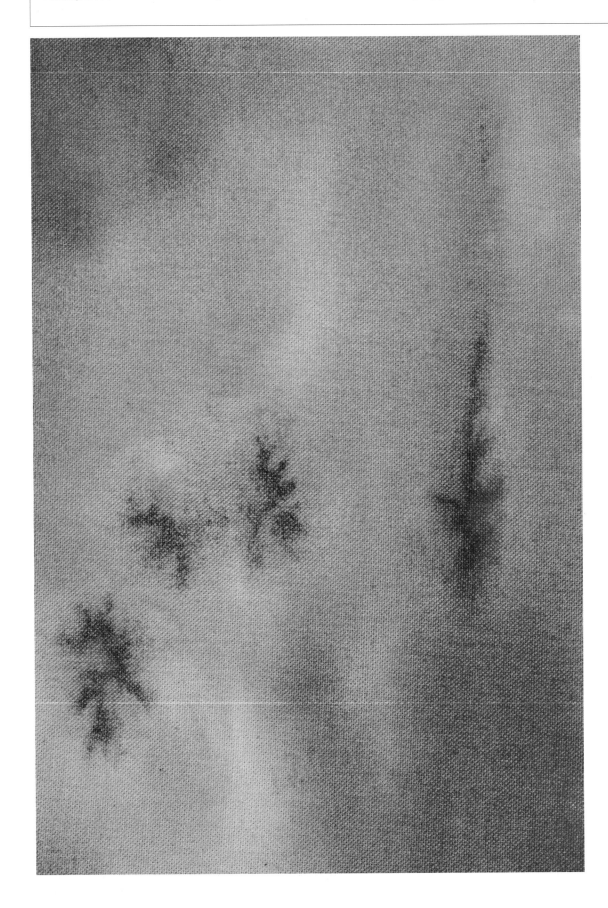

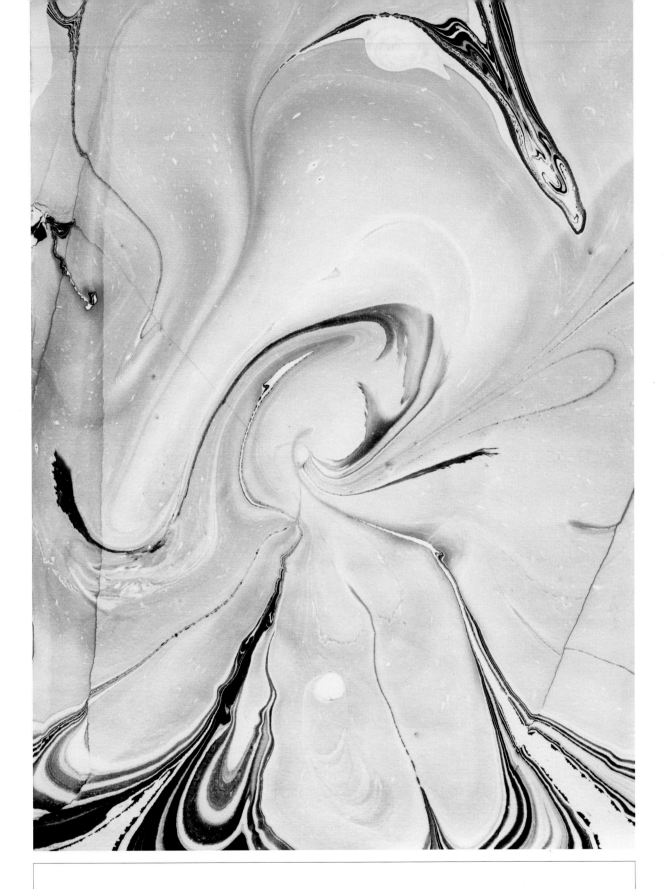

Using the Marbling technique, a bull's-eye pattern was created with alternating drops of Carbon Black and Titanium White. The pattern was continued using Transparent Phthalo Blue and straight Airbrush Medium. A drinking straw was used to distort the floating paint before it was transferred to Hahnemühle Ingres paper.

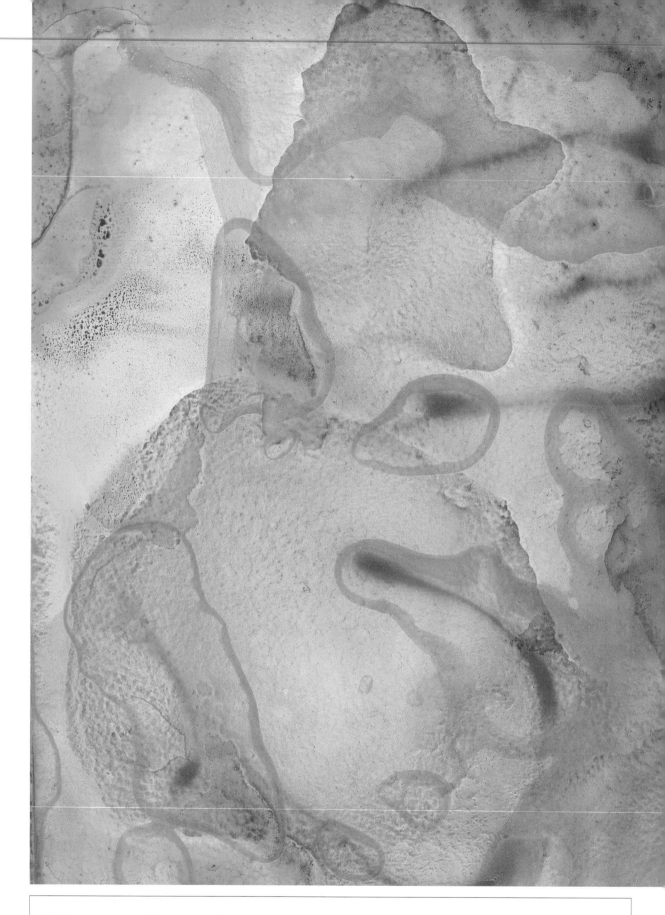

Various watery glazes were layered one at a time over a loose sheet of 140 lb. watercolor paper, forcing it to buckle and allowing each glaze to form irregular puddles. Each layer was allowed to dry before the next was applied.

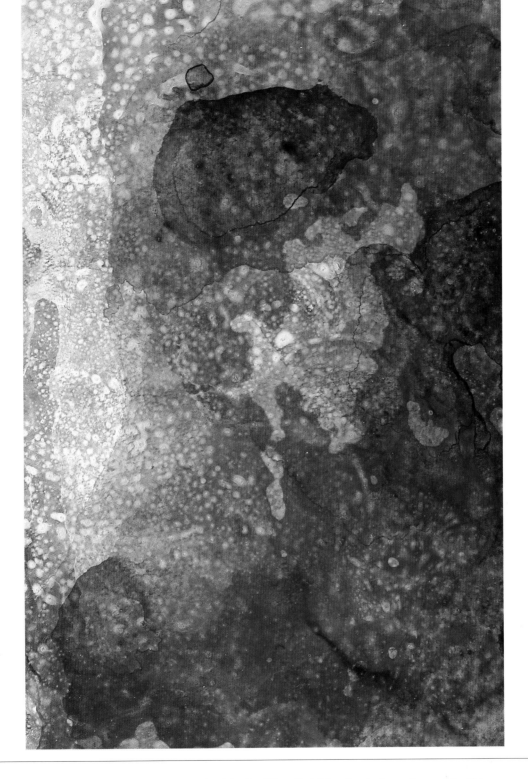

The Palimpsest technique was combined with the Tiny Bubbles technique to create this layered composition.

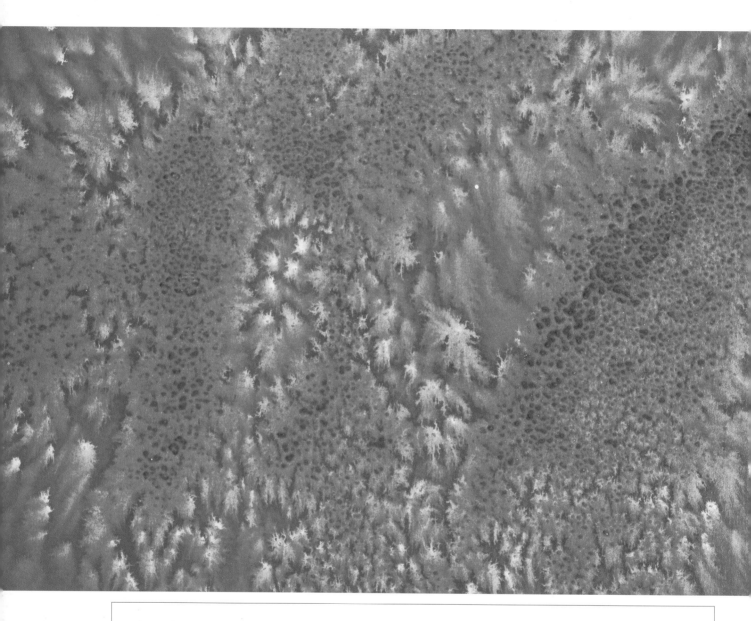

The Salt Effect technique was used here over a wash of Phthalo Blue, Titanium White, and distilled water.

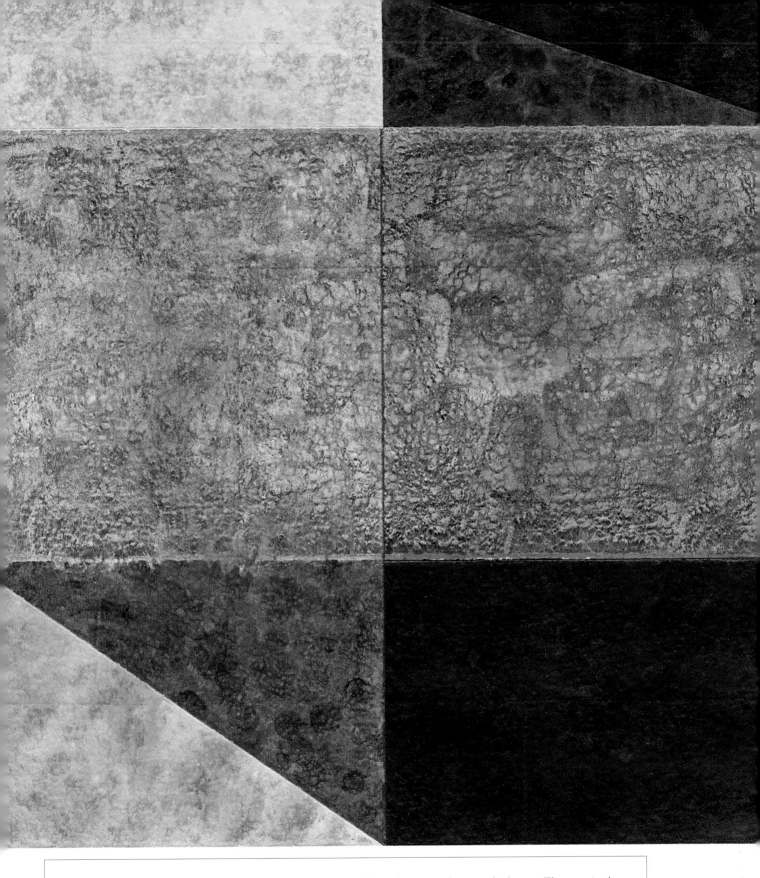

Hard-edge shapes were taped off and built up with various washes and glazes. The central horizontal band was treated with one layer of a Titanium White wash, in which the pigment and binder began to separate, creating an interesting organic texture. A final glaze was used to seal the surface.

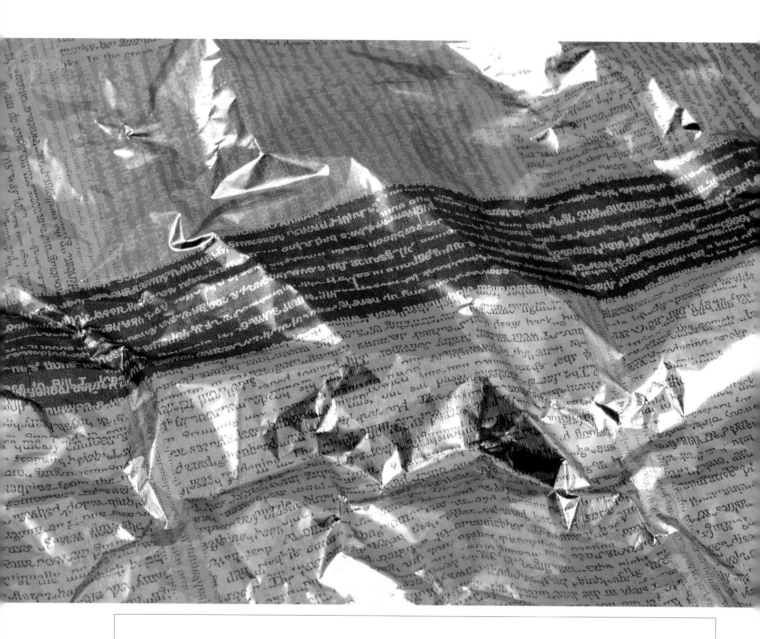

A collage made using the Text as Texture technique was photographed, reduced to a high-contrast black and white image, and then printed with a standard ink-jet printer onto a sheet of aluminum foil coated with Golden Digital Ground for Non-Porous Surfaces.

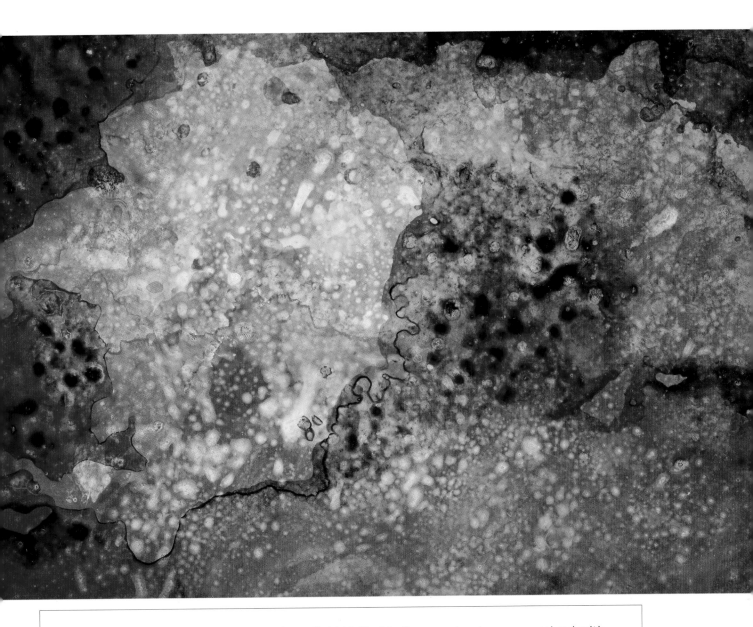

Various glazes—made with fluid acrylics, Fluid Matte Medium, and water—were mixed with a small amount of liquid soap. Each layer of color was applied, allowed to partially dry, and then wiped off, leaving organically formed areas of color, through which previous layers became visible.

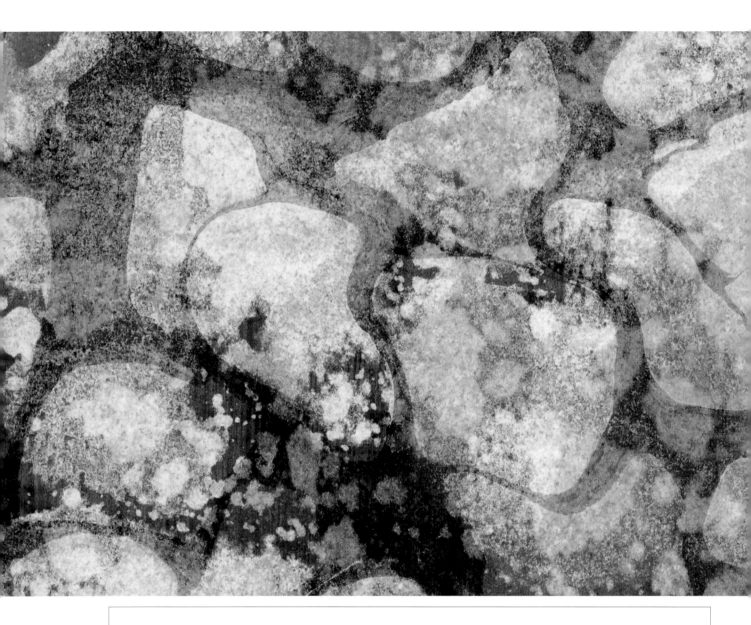

Here, a sheet of Lenox paper was used to transfer a marbled surface made using only Carbon Black and Titanium White. The sheet was then coated with a Phthalo Blue glaze, sprayed with water, and blotted with newsprint.

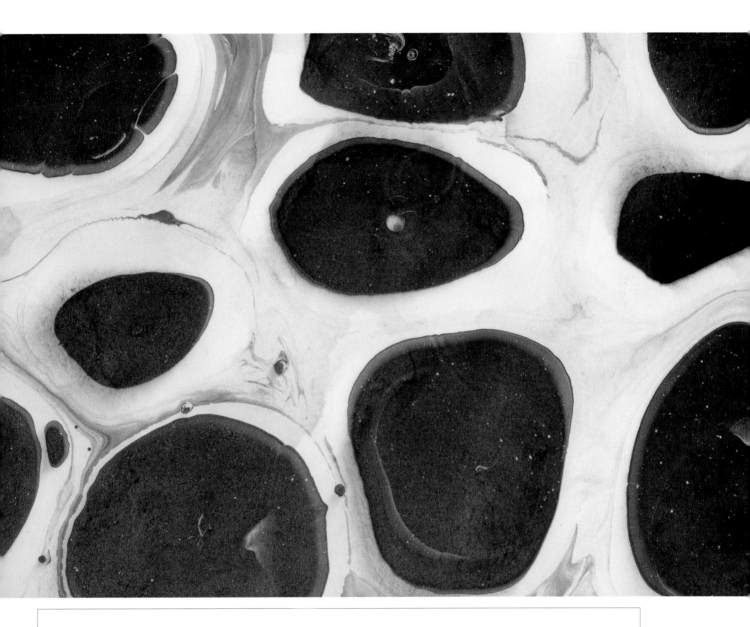

The Marbling technique was used here, with repeated drops of Carbon Black added to the surface to form large stone-like shapes. The floating paint was then transferred to Masa paper.

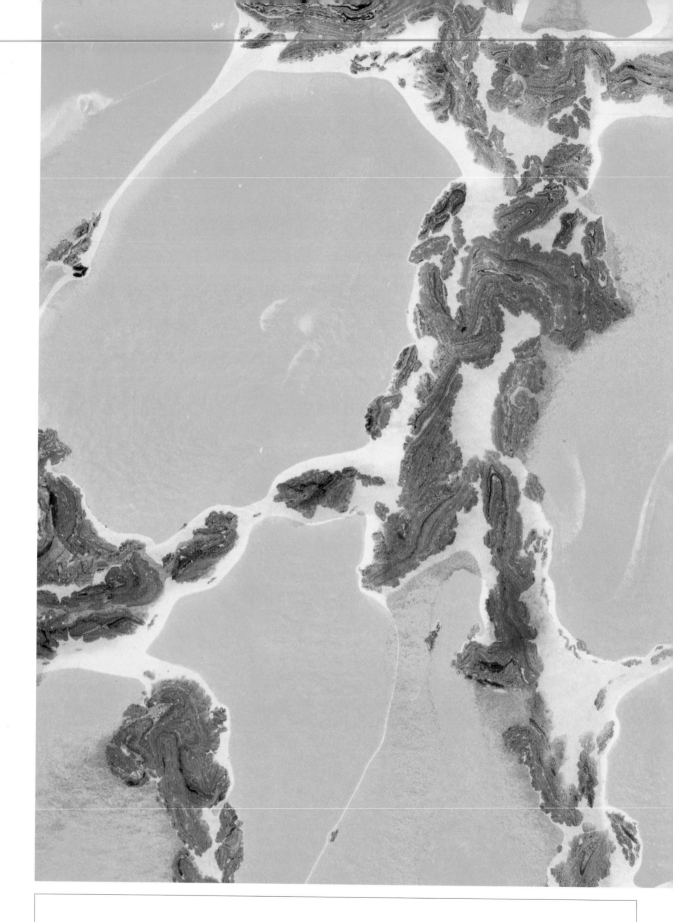

Using the Marbling technique, straight Diarylide Yellow Airbrush Paint was used to create a bold contrast to the black and white portion of this marble pattern on Lenox paper.

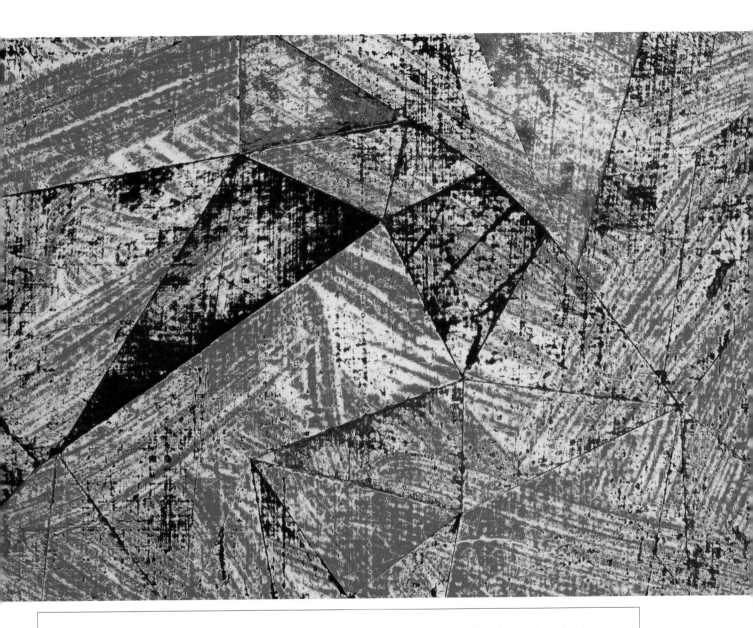

A foundation of geometric shapes was created, and then covered with a loose, brushy layer of red fluid acrylic. The entire surface was then sanded with an electric palm sander, exposing the shapes beneath the surface.

RESOURCES

{ UNITED STATES }

A.C. MOORE
www.acmoore.com

DANIEL SMITH
www.danielsmith.com

DICK BLICK
www.dickblick.com

HOBBY LOBBY
www.hobbylobby.com

JO-ANN FABRIC AND CRAFT STORES
www.joann.com

MICHAELS
www.michaels.com

UTRECHT
www.utrechtart.com

SUPPORTS
AMPERSAND ART SUPPLY
www.ampersandart.com

MARBLING SUPPLIES
PRO CHEMICAL AND DYE
www.prochemicalanddye.com

PRODUCT INFORMATION
GOLDEN ARTIST COLORS
www.goldenpaints.com

HOMASOTE BOARD
www.homasote.com

PREVAL SPRAYER
www.preval.com

{ AUSTRALIA }

ECKERSLEY'S ARTS, CRAFTS,
AND IMAGINATION
www.eckersleys.com.au

{ CANADA }

CURRY'S ART STORE
www.currys.com

DESERRES
www.deserres.ca

MICHAELS
www.michaels.com

{ FRANCE }

GRAPHIGRO
www.graphigro.com

{ ITALY }

VERTECCHI
www.vertecchi.com

{ NEW ZEALAND }

LITTLEJOHNS ART &
GRAPHIC SUPPLIES LTD.
170 Victoria Street
Wellington, New Zealand
04 385 2099

{ UK }

CREATIVE CRAFTS
www.creativecrafts.co.uk

HOBBYCRAFT GROUP LIMITED
www.hobbycraft.co.uk

JOHN LEWIS
www.johnlewis.co.uk

T N LAWRENCE & SON LTD.
www.lawrence.co.uk

ABOUT THE AUTHOR

DAN TRANBERG lives and works in Cleveland, Ohio, where he teaches painting and writing at the Cleveland Institute of Art. He has published more than 750 articles on art and has exhibited his paintings in more that 40 exhibitions. His writing has appeared in national and international publications, including *Art in America*, *NY Arts*, *artUS*, *BOMB*, *Glass Magazine*, and *Art on Paper*. He received a M.A. in studio art from Purdue University, and a B.F.A. in ceramics from Northern Illinois University. He was awarded an Ohio Excellence in Journalism award in 2004 and received Ohio Arts Council Individual Artist Fellowships in 2002 and 2007.

www.dantranberg.com
www.acrylicfusionthebook.com

ACKNOWLEDGMENTS

I am extremely grateful to my editor, Mary Ann Hall, who was as calm and patient throughout this project as I was stressed and frenzied, and to my partner and unofficial editor, Terry Durst, who provided frequent feedback on text and images, and did far more than his share of dishes and dog walking while this book was being produced.